SACRAMENTO
IMPRESSIONS

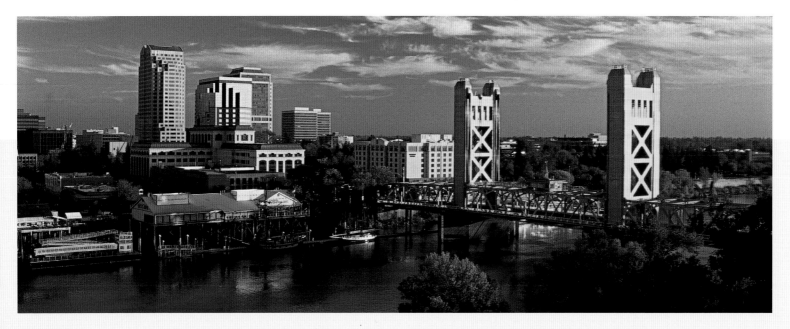

photography by

TOM, SALLY, AND JEFF MYERS

foreword by

HEATHER FARGO

FARCOUNTRY
PRESS
HELENA, MONTANA

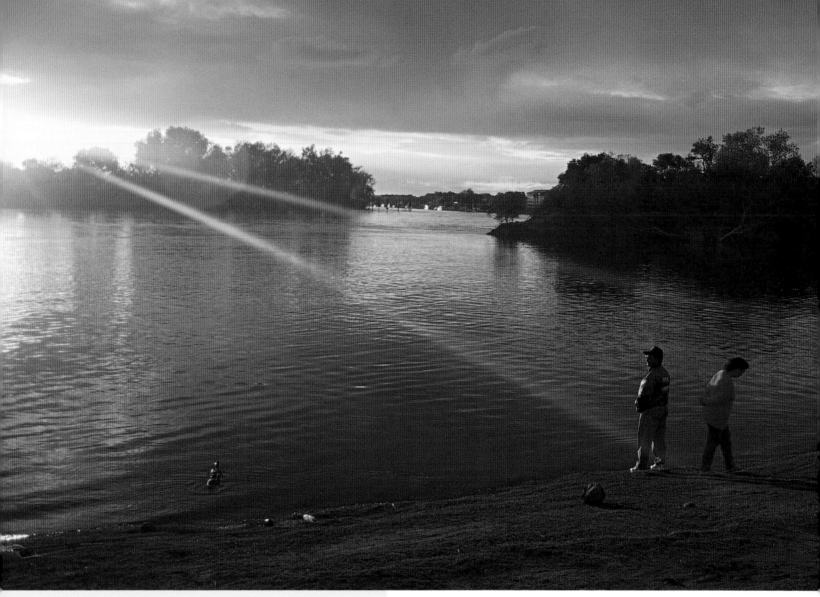

FRONT COVER: Downtown Sacramento, the skies overhead painted in shades of pink and purple.

BACK COVER: Wild times during the annual Gold Rush Days.

TITLE PAGE: The Sacramento waterfront, with Tower Bridge in the foreground.

ISBN 10: 1-56037-464-0
ISBN 13: 978-1-56037-464-0

© 2007 BY FARCOUNTRY PRESS
PHOTOGRAPHY © 2007 BY TOM, SALLY, AND JEFF MYERS

FOR MORE INFORMATION ABOUT OUR BOOKS, WRITE FARCOUNTRY PRESS, P.O. BOX 5630, HELENA, MT 59604; CALL (800) 821-3874; OR VISIT WWW.FARCOUNTRYPRESS.COM.

CREATED, PRODUCED, AND DESIGNED IN THE UNITED STATES.
PRINTED IN CHINA.

12 11 10 09 08 07 1 2 3 4 5 6

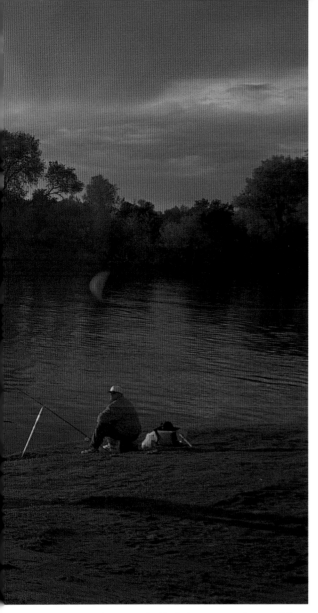

ABOVE: Discovery Park's 275 acres provide great fishing and water-gazing within the city limits of Sacramento.

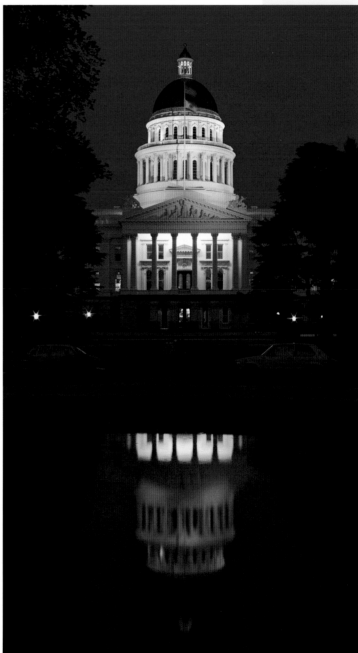

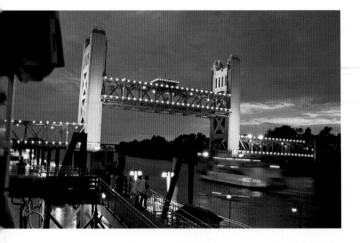

Sacramento is a city of great history. From its roots, when the area was inhabited by Native Americans, the area has seen waves of migrants, ranging from the early Spanish explorers to the onrush of European settlers to the Forty-niners, who came flooding into California during the Gold Rush. Originally called New Helvetica by settler John Sutter, Sacramento has seen a tidal wave of change that is ongoing, just as migration to California has become an ongoing national—indeed an international—obsession.

Located in the heart of California, Sacramento was destined to become the center of government for one of the largest economies in the world. Embraced by two beautiful rivers—the Sacramento and the American—Sacramento early on became a transportation hub for northern California. Because of the presence of the transcontinental railroad and the city's proximity to the gold fields, Sacramento became a bustling depot and shipping port during the Gold Rush of the mid-nineteenth century. This was followed by the network of freeways and airports that crisscrossed the area in the twentieth century. The area's transportation legacy is with us today as we engage in business throughout the great state of California and the world.

The production of fruits, vegetables, and rice in the fertile Sacramento Valley has also played a critical role in the history of our city, creating much of the trade and commerce that fueled Sacramento's economic growth. These same fields also provide our residents with the peace and tranquility of living close to the natural world.

Part of the Pacific Flyway, the skies over Sacramento are a migratory pathway for some of the world's most beautiful and majestic birds. Native species of fish, reptiles, birds, trees, flowers, and grasses decorate the surrounding landscape and are a critical reason why people choose to make Sacramento their home.

Sacramento is called the "City of Trees." This beautiful canopy of deciduous, evergreen, fruit, flowering, and palm trees that make up Sacramento's six million trees keeps us cool in the spring and summer, and, in fall, paints Sacramento with amazing colors of red, yellow, and orange that makes you feel you are part of a master's oil painting.

Because of the natural beauty that surrounds us, Sacramento is a city of active people who enjoy the outdoors. We enjoy baseball, basketball, bicycling, boating, cricket, gardening, rugby, running, soccer, and walking—anything that keeps us outside and in contact with

Sacramento's fabulous weather. Every park, every jogging trail, and every playing field is busy throughout Sacramento. The great weather, cultural diversity, friendly atmosphere, and local events attract residents and tourists alike.

Summer days can be hot, but as any Sacramentan will remind you, it is a dry heat. Hot days cool down quickly with the fast-moving breezes that blow from the Pacific Ocean through the Delta and on into Sacramento. Winters can be wet and foggy, but they often give way to glorious days, when the sun is warm and windows are wide open.

Sacramento is a growing city, with urban amenities and a great lifestyle that maintains a small-town feel. Our city's greatest attributes are the rivers, the surrounding open fields, and the incredible vistas of the mountains—the snow-capped Sierra Nevadas, the Coastal Range, and the Sutter Buttes.

The Myers' photographs show us this city on the rise—where new generations of new residents anchor their families and enjoy this special spot in the Central Valley. A recent study published in *Time* identified Sacramento as America's most integrated city, observing that in "Sacramento, people seem to live side by side more successfully." We are proud of our citizens, our history, and our cultures. It is because of the history of our residents that makes Sacramento the great city it is today.

Tom, Sally, and Jeff Myers know Sacramento well, and in this wonderful collection, they do the impossible. They capture the essence, energy, and feel of our great city. Only the Myers could, in a photograph, capture all of the qualities that characterize daily life in Sacramento today.

In their photographs, I can smell the cooking from drifting BBQ picnics in the picture of Land Park, and I can hear children squealing with delight from the small rides in Funderland. I see their pictures of Old Sacramento and can feel the warmth of the sun and hear the sound of jazz playing and crowds cheering during the annual Sacramento Jazz Jubilee. When I see the pictures of neighborhoods lined with trees and imagine walking on those very streets, I am filled with the pride of being the mayor of such a beautiful, diverse, and exciting city.

Come walk with me through this fine city as you enjoy these photographs capturing the spirit and the soul of Sacramento.

HEATHER FARGO
Mayor
City of Sacramento

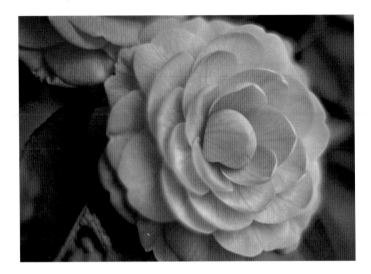

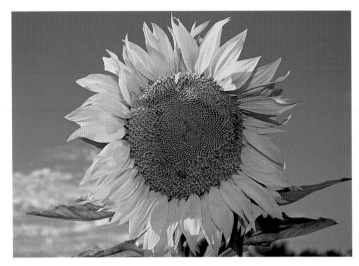

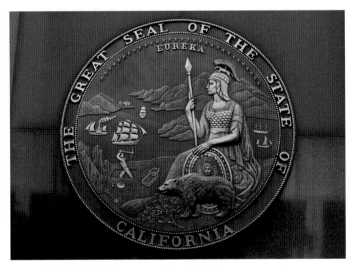

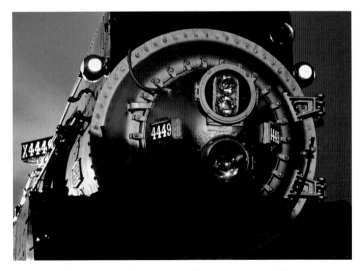

ABOVE: In the 1920s, Sacramento claimed the fragrant camellia as its official flower.

BELOW: California's seal incorporates symbols of the state's natural beauty, commerce, and opportunity.

ABOVE: Sunflowers remind visitors that they are in sunny California.

BELOW: A lavishly restored engine shines like new at the California State Railroad Museum.

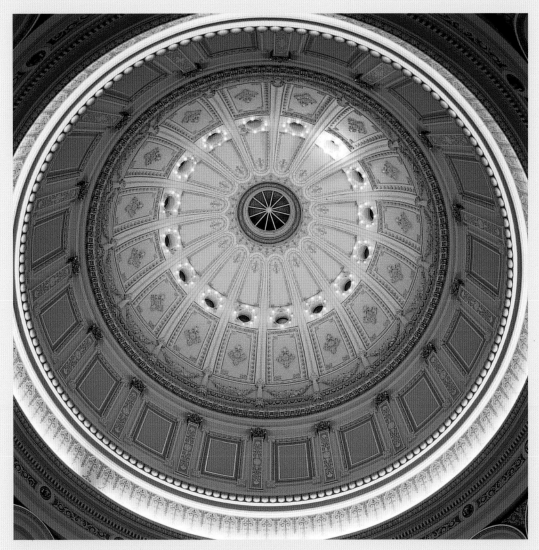

The capitol's ornate dome above the rotunda reflects its Victorian-era origins.

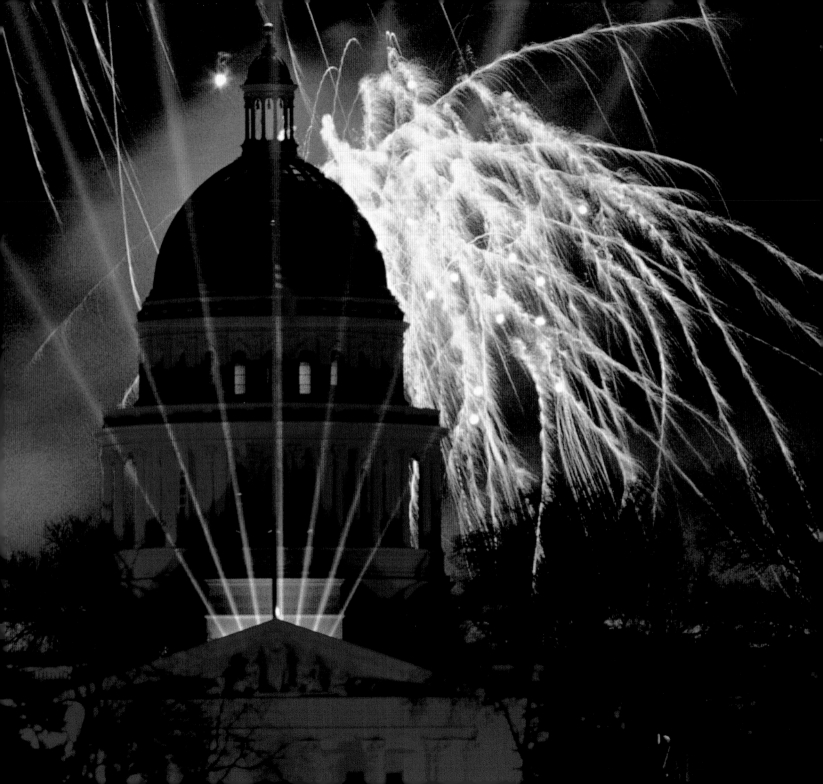

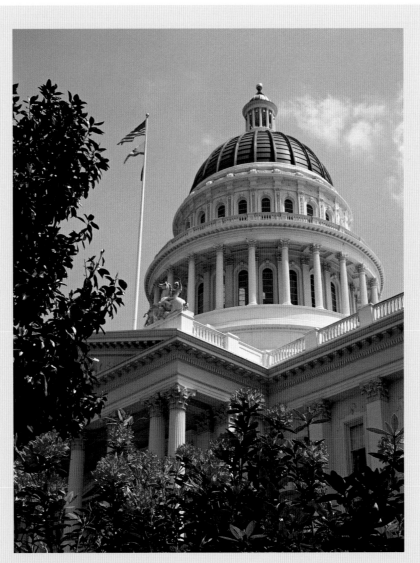

FACING PAGE: The $68 million capitol restoration was celebrated with a dazzling fireworks display at a gala opening in January 1982.

ABOVE: The capitol is in springtime regalia, skirted by blooming rhododendrons.

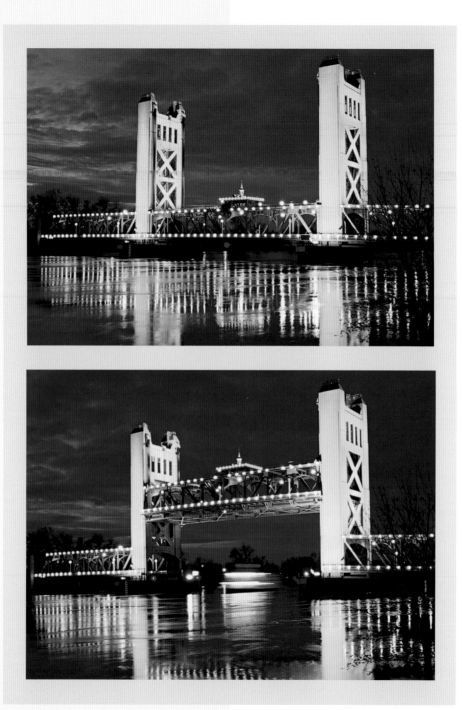

The Tower Bridge, opened in 1935, was California's first vertical lift bridge. It rises 100 feet to allow tall boat traffic on the Sacramento River to pass.

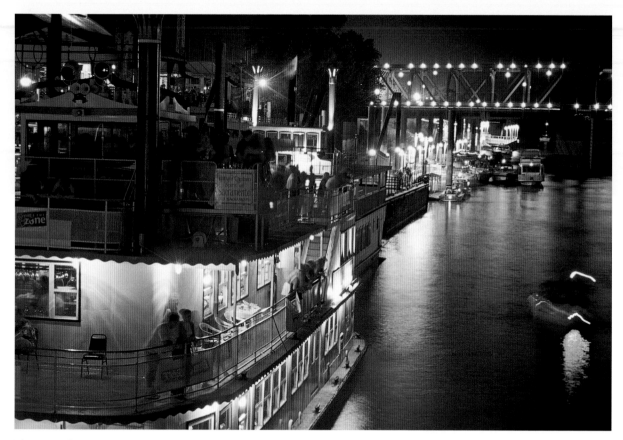

The *Spirit of Sacramento* departs from Old Sacramento and cruises the
Sacramento River, providing sightseers a unique view of the city.

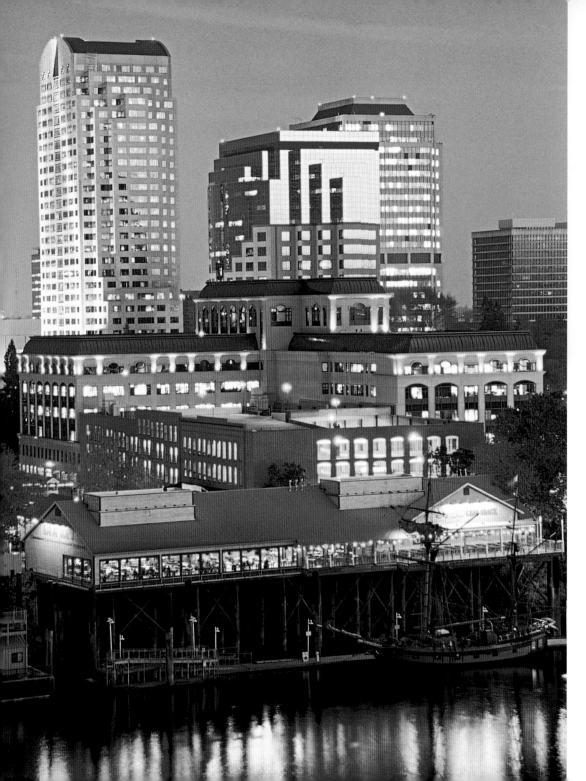

Sacramento's waterfront
and downtown buzz nightly
with renowned dining and
entertainment.

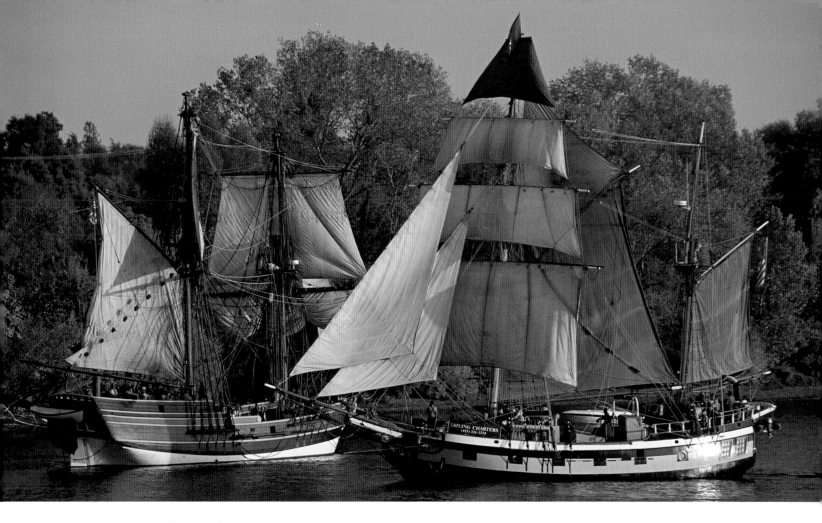

ABOVE: The nonprofit organization Call of the Sea brings these tall ships to Sacramento once a year. Its mission is to connect people to the sea through unique hands-on programs explaining traditional vessels.

RIGHT: There's never a traffic jam when you take a water taxi to one of the many waterfront restaurants.

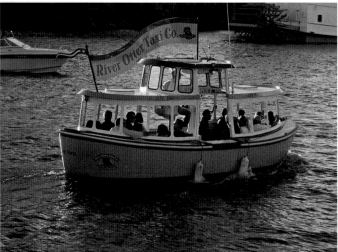

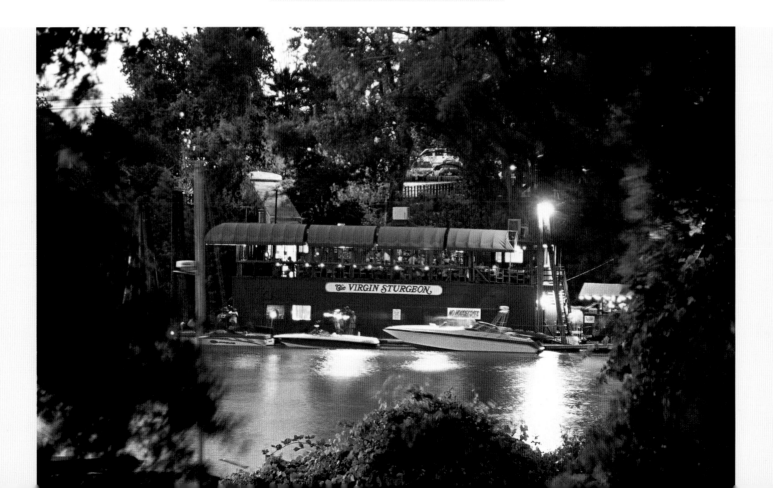

LEFT: Old Sacramento is uniquely set up for entertaining visitors, with numerous attractions, activities, and restaurants, and access to the sightseeing riverboat cruises.

BELOW: The Virgin Sturgeon restaurant, in a permanently docked riverboat on the Sacramento River, offers a fabulous view and a casual dining atmosphere.

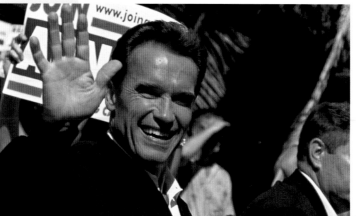

LEFT: Austrian-born Arnold Schwarzenegger became a U.S. citizen in 1983 and now serves as California's 38th governor, first elected in 2003 and re-elected in 2006.

ABOVE AND RIGHT: A large crowd gathered at the capitol to commemorate the nation's 9/11 tragedy.

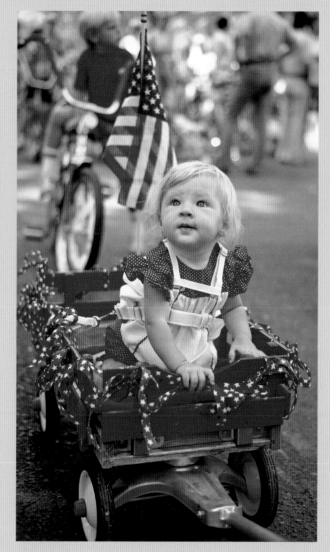

ABOVE: California First Lady Maria Shriver is an award-winning journalist and a book author; here she is signing one of her children's books.

ABOVE: Children are an important part of this neighborhood's Independence Day parade.

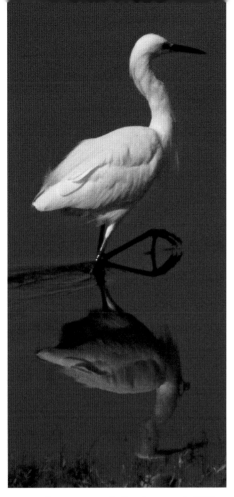

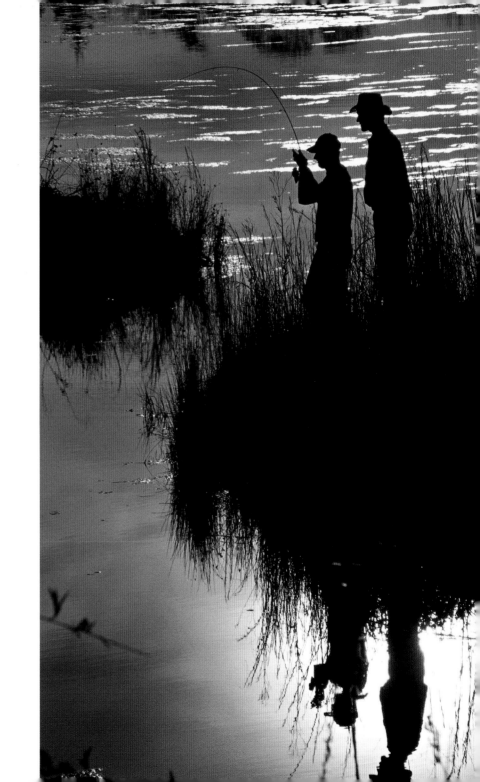

ABOVE: A snowy egret finds calm water in William B. Pond County Recreation Area, on the American River Parkway. Egrets are in the heron family, subsisting on fish and crustaceans.

RIGHT: The large, man-made fishing hole in William B. Pond County Recreation Area is stocked with trout and catfish and is home to bass, bluegill, and tule perch.

FACING PAGE: More than 5 million people visit the 23-mile-long American River Parkway each year. Recreation includes wildlife watching, fishing, boating, picnicking, golfing, and guided tours.

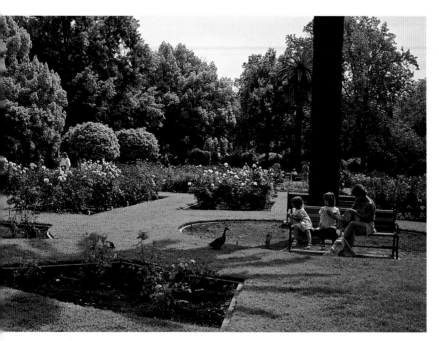

McKinley Park Rose Garden, created in 1928, features more than 1,000 rose bushes, tree roses, and blooming annuals. Visitors can stroll the grassy pathways throughout the 1.5-acre park.

Cesar Chavez Plaza in downtown Sacramento hosts a summer evening concert series and a hopping farmer's market during the growing season.

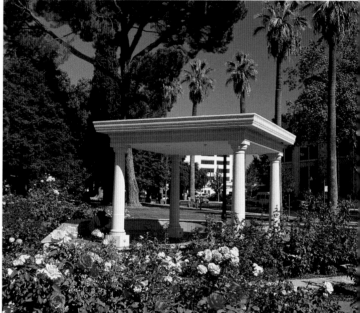

The World Peace Rose Garden on the California State Capitol grounds features more than 153 varieties of roses. The rose is the official flower of the United States, and many here bear names that refer to peace, such as Lasting Peace Rose, Love & Peace, and Glowing Peace.

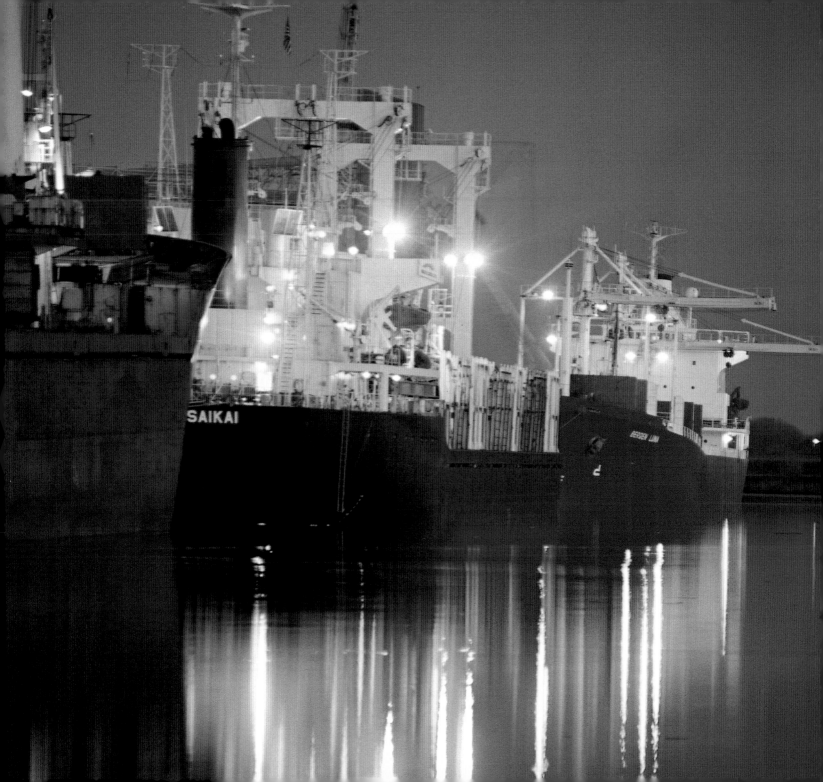

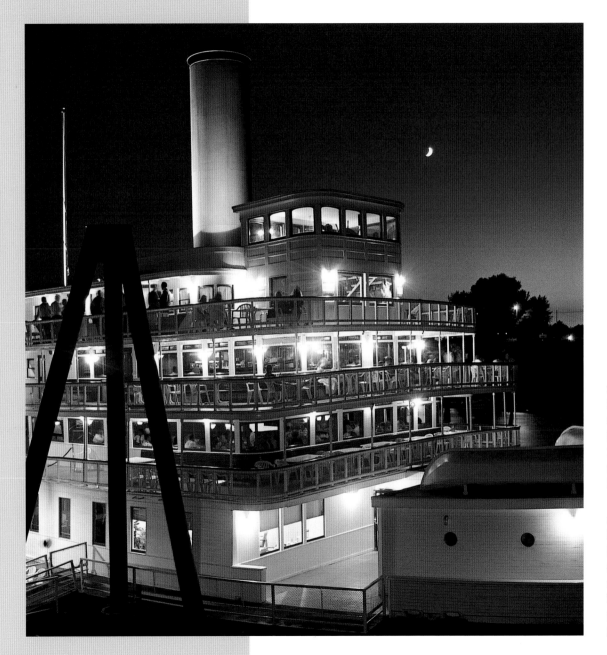

LEFT: Brilliantly lit decks of the *Delta King* beckon diners aboard to sample the fare. Between 1927 and the late 1930s, the 285-foot *Delta King* carried passengers between Sacramento and San Francisco.

FACING PAGE: The inland Port of Sacramento in West Sacramento opened in 1963 and now handles about 1.3 million tons annually, primarily bulk commodities such as rice and grains grown in this rich agricultural region.

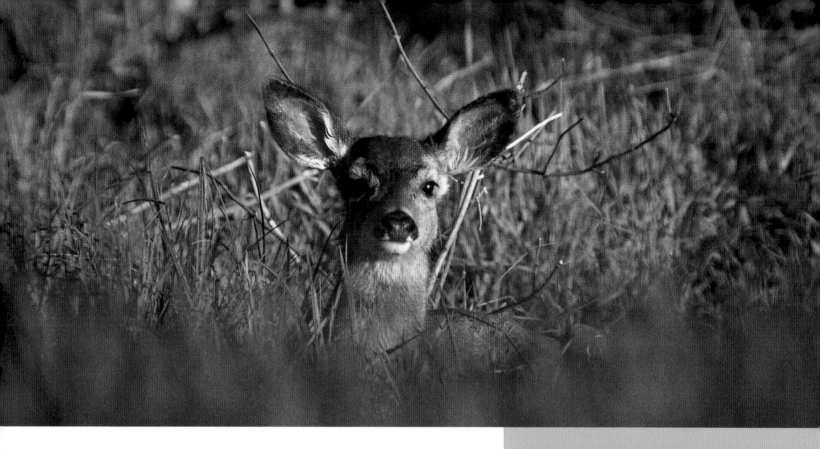

ABOVE: A black-tailed deer fawn rests in the deep grass in Sacramento County's C. M. Goethe Park (pronounced *GAH-tee*). You may also spot a wild turkey if you hike or ride a horse through the park's 444 acres.

RIGHT: More than fourteen species of hummingbirds occur in California. This black-chinned hummingbird is raising its young in a Sacramento back yard.

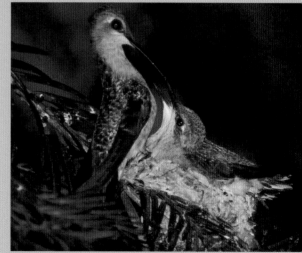

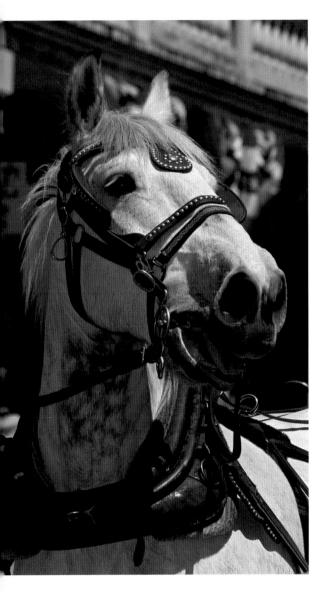

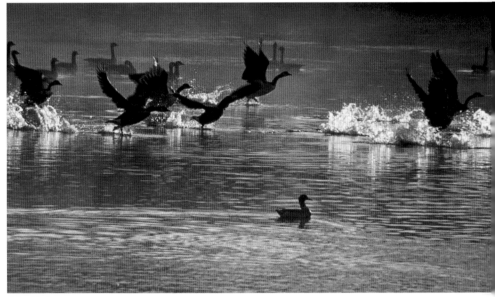

ABOVE: Waterfowl get a running start in order to launch into flight on the American River.

LEFT: Diversions in Old Sacramento include riding in a horse-drawn carriage pulled by a handsome steed. This 28-acre state historic park on the Sacramento River is also a National Historic Landmark.

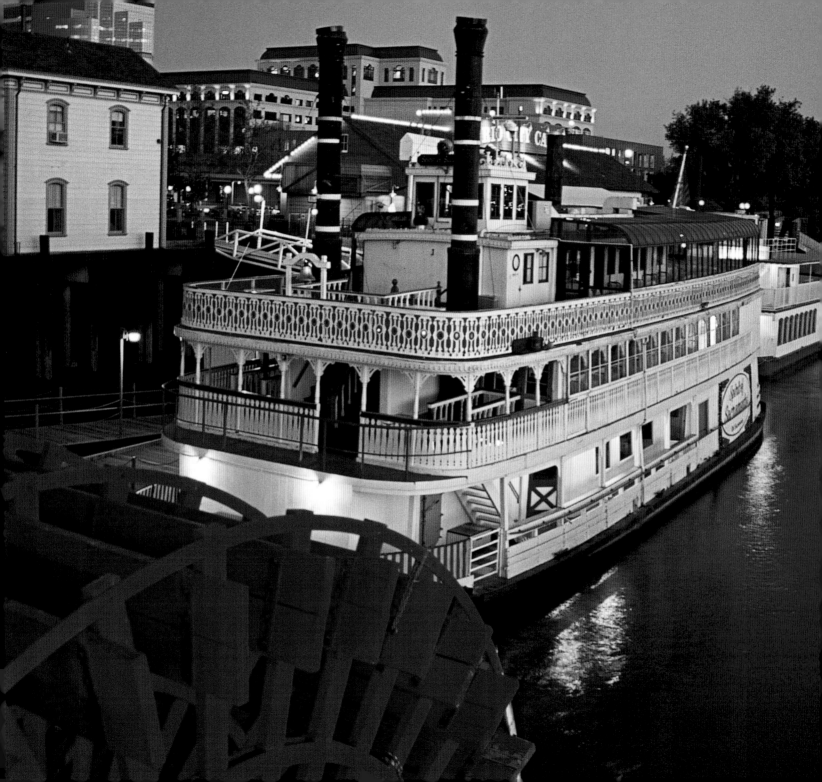

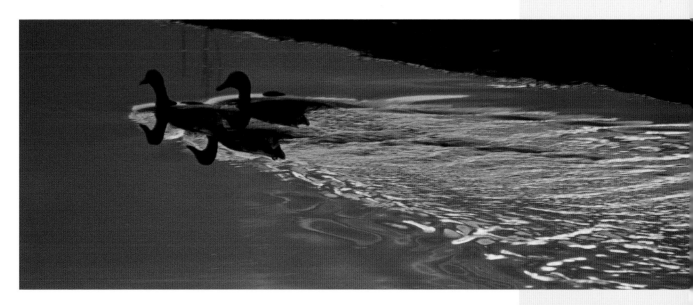

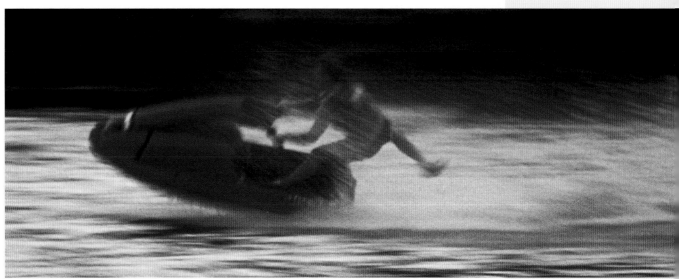

FACING PAGE: The *Spirit of Sacramento,* which offers dinner and sightseeing cruises, is permanently docked at the Old Sacramento waterfront. Its red paddlewheel once belonged to the *Delta King*.

ABOVE: Wild times occur on the Sacramento River as wild waterfowl swim serenely in the deepening dusk; a daredevil barely stays on for a speeding wild ride.

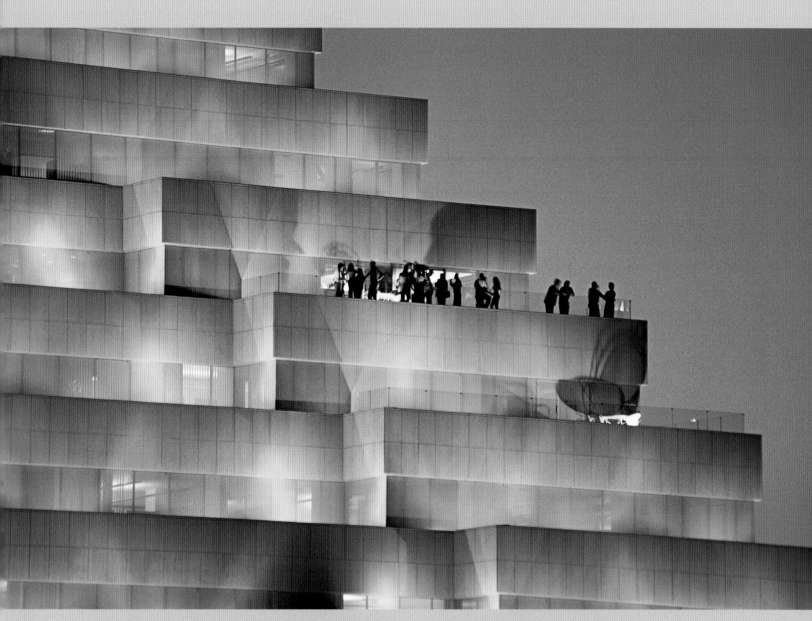

The state Department of General Services has its offices in the unique and eye-catching Ziggurat Building located in West Sacramento.

RIGHT: The Library Galleria complex towers above the street and includes the unique glass structure to the right.

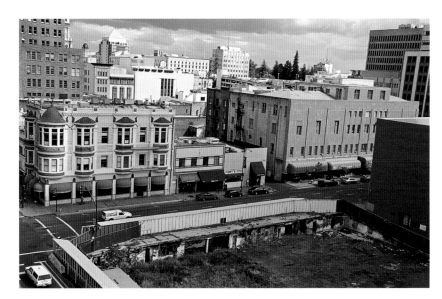

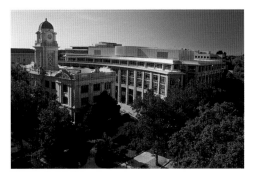

ABOVE: The City of Sacramento, in Sacramento County, was founded in 1849. It is the Golden State's oldest incorporated city. Its varied architecture reflects the city's long history. The empty lot (above) also shows the original level of the city's streets, which were raised because of repeated flooding.

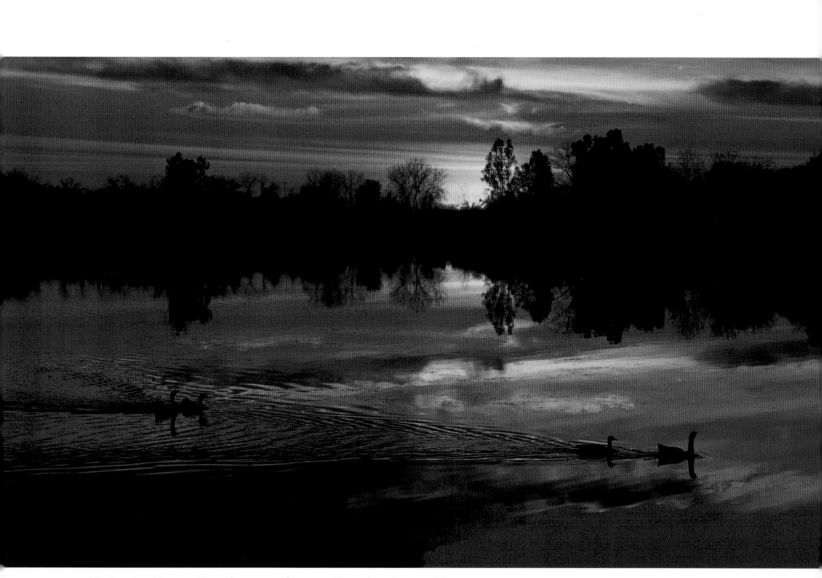

The American River provides welcome natural beauty within walking distance of skyscrapers.

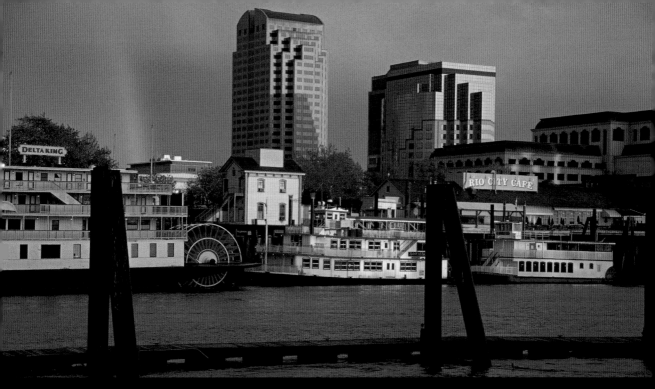

One of Sacramento's distinguishing charms is the way residents have seamlessly blended river life and city life.

FACING PAGE: Kevin Martin, of the Sacramento Kings, is one reason the home team fills the stadium with cheering fans. PHOTO BY ROCKY WIDNER / NBAE / GETTY IMAGES

RIGHT AND BELOW: The Sacramento River Cats logo welcomes a full house to a game at Raley Field, home turf of this Oakland Athletics Triple-A affiliate and two-time PCL champion. Raley Field also brings in crowds for numerous concerts, community celebrations, festivals, and private events.

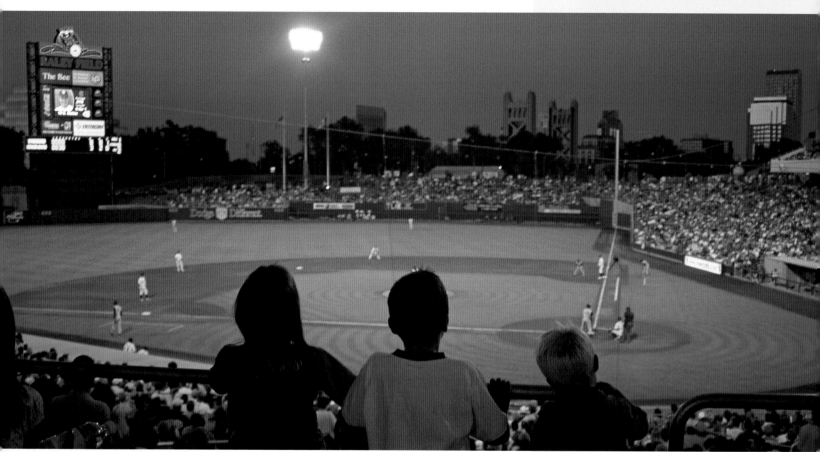

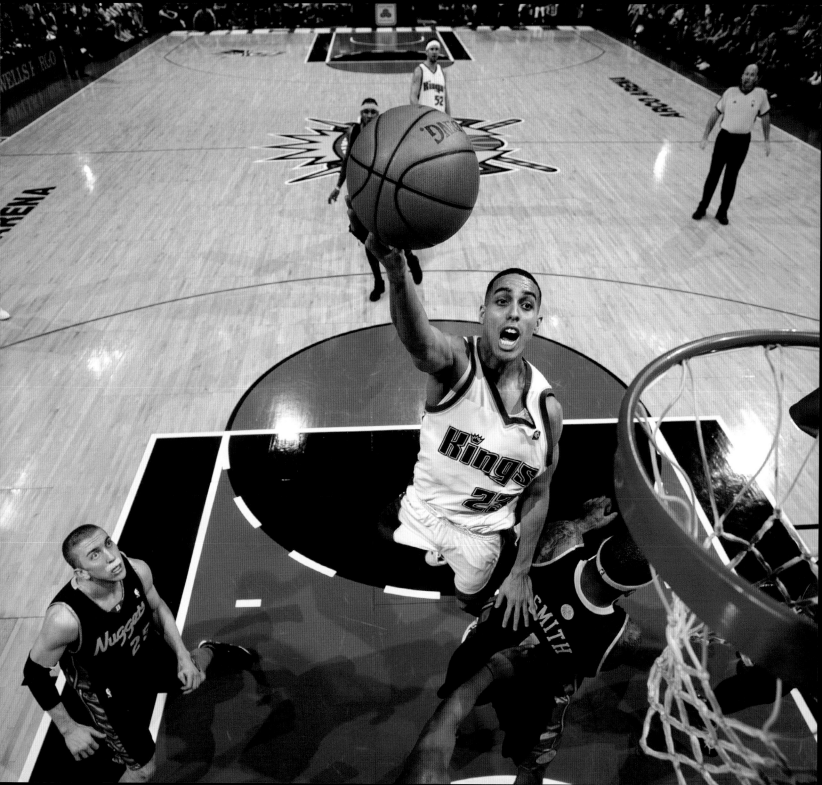

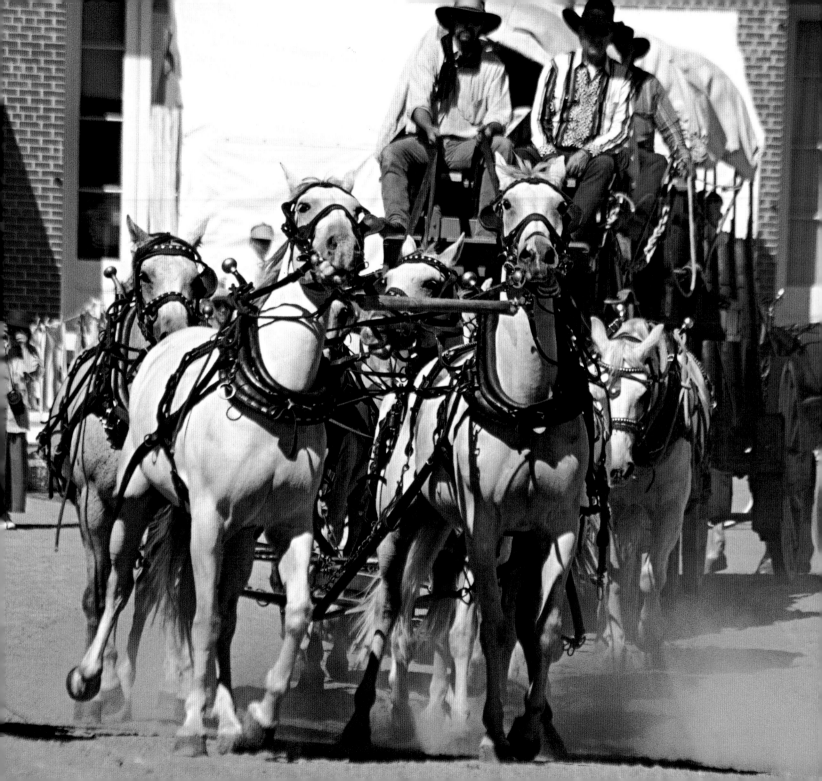

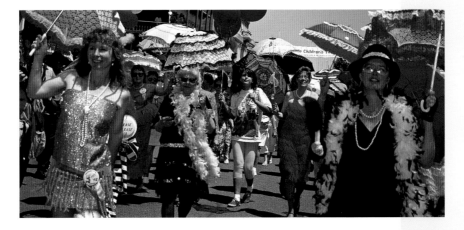

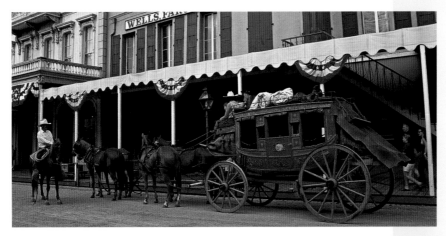

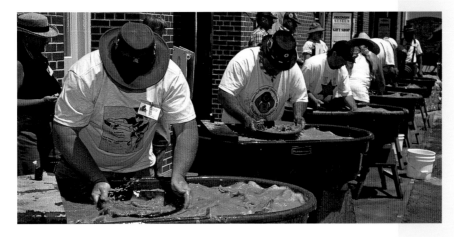

FACING PAGE: Labor Day weekend brings the annual festivities of Gold Rush Days to Old Sacramento. Events include wagon rides, gold panning, minstrels, dancing, story-telling, and re-enactments of Old West shenanigans.

TOP: Sacramento's Jazz Jubilee launches Memorial Day weekend with a swinging parade, followed by four days of fabulous music at more than thirty venues along the Sacramento River.

MIDDLE: The Wells Fargo stagecoach pulls up to the bank during the yearly Gold Rush Days. In a situation like this, you never know if there might be a holdup involved…

BOTTOM: Feverishly looking for "color": a gold-panning contest at the Discovery Museum's Gold Rush History Center in Old Sacramento. The museum enlightens visitors about California's gold-fever past and Sacramento's growth during the mid-1800s.

RIGHT: Franciscan missionary Father Junipero Serra planted California's first vineyard at Mission San Diego in 1769. By 1900, California had an award-winning commercial grape-growing and wine-making industry.

BELOW: California poppies adorn a field outside Sacramento. The poppy was designated California's official state flower in 1903; its ubiquitous golden blooms blanket much of the state in springtime. Each April 6, residents celebrate California Poppy Day.

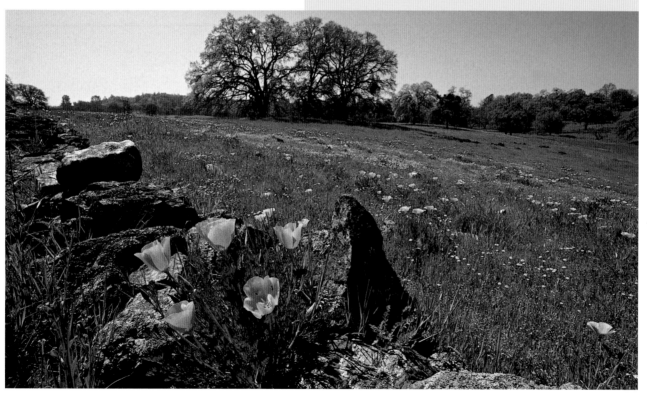

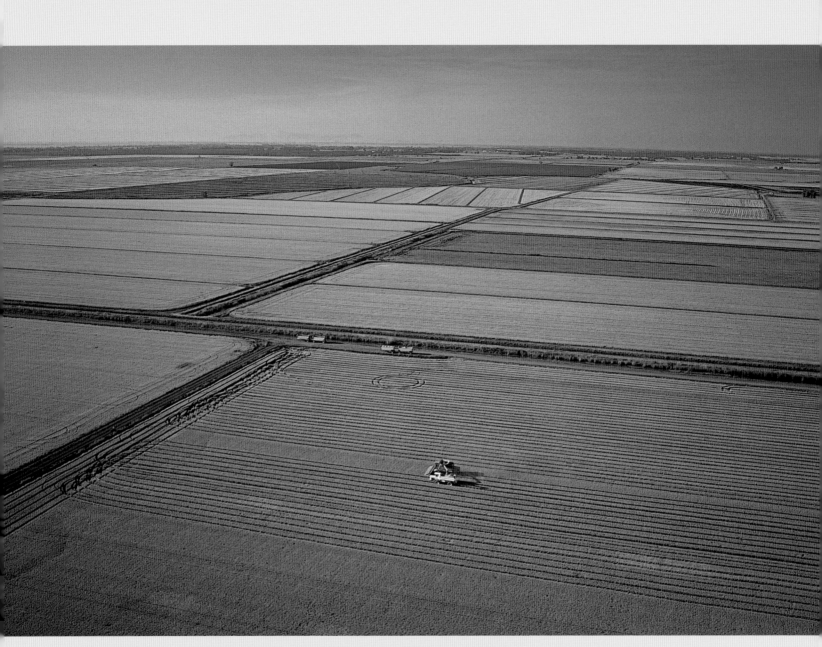

Fields of rice grow in Sacramento and Sutter counties. Nearly 2 million metric tons of rice are grown annually in California; more than 95 percent of that is grown in the Sacramento Valley.

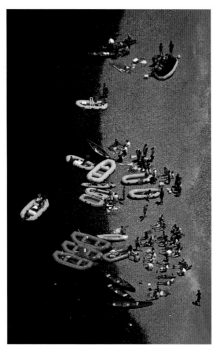

ABOVE: Rafters pull up onto the American River shoreline to relax. Each year, thousands of boaters head for all three forks of the American for long, wild whitewater runs as well as relaxing day floats.

RIGHT: A fleet of catamarans is rigged and ready to sail in a regatta on Folsom Lake. The temperate year-round climate around Sacramento encourages many residents to take up boating as a way to enjoy the great outdoors.

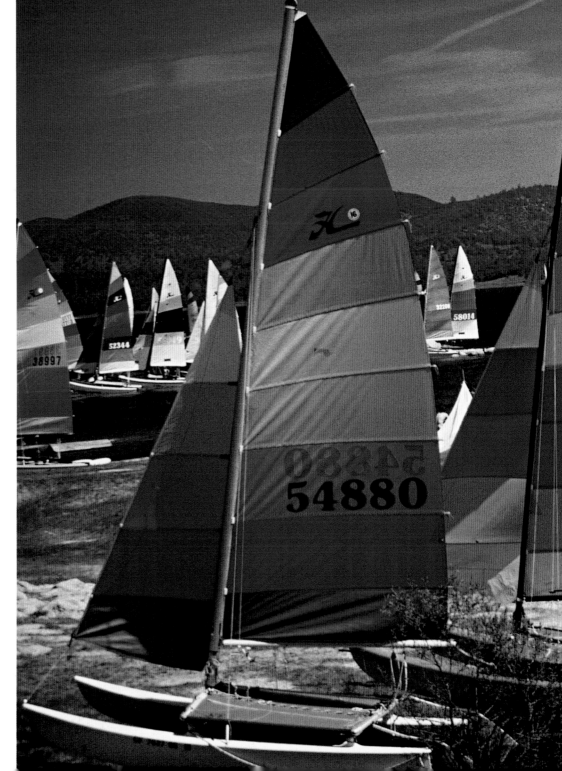

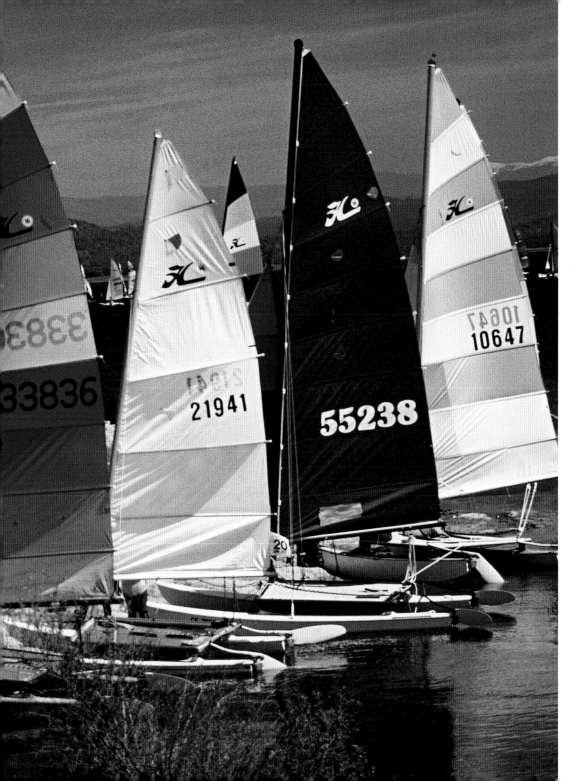

With more room in the rafts than in the car, this crew is headed for cooling, splashing fun on the American River.

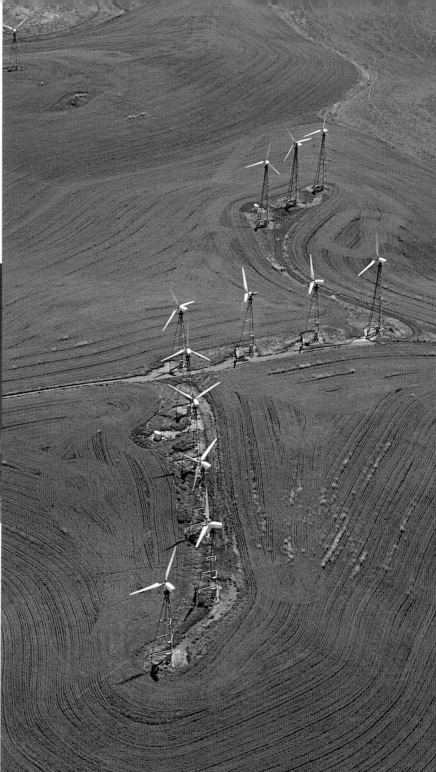

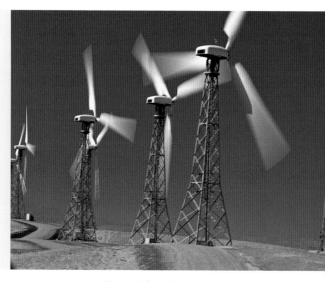

ABOVE AND RIGHT: These 15-foot wind turbines generate up to 39 megawatts of electricity when the wind speed reaches 30 mph. The turbines can generate power with as little as 8 mph of wind speed, and continue to operate in winds up to 56 mph. These new, renewable-energy generators are in a Montezuma Hills pasture near the Sacramento River.

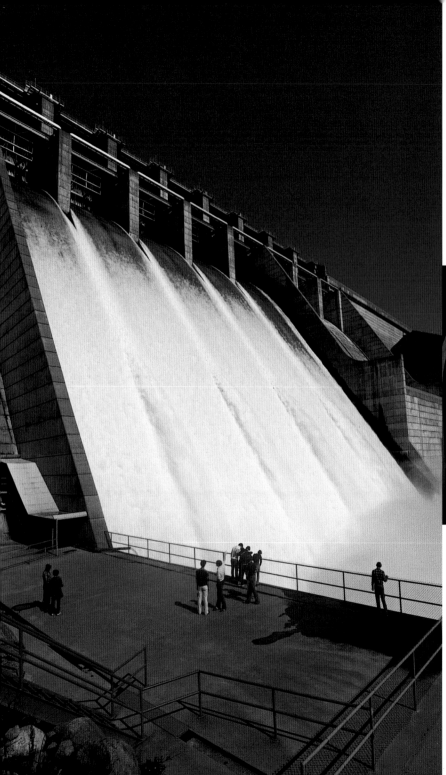

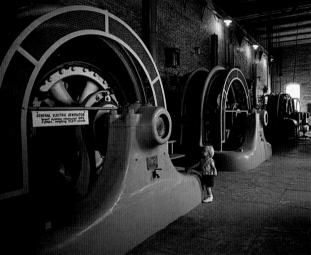

ABOVE: The Folsom Powerhouse on the American River was once called "the greatest operative electrical plant on the American continent." From 1885 to 1952 it regularly produced 11,000 volts of electricity for Sacramento

LEFT: Folsom Dam, completed in May 1956, is 340 feet high and 1,400 feet long. The power plant has three generators that provide 198,720 kilowatts of electrical power, enough electricity to light 2 million 100-watt bulbs for one hour. It is preserved as a state historic park, with a self-guided interpretive tour.

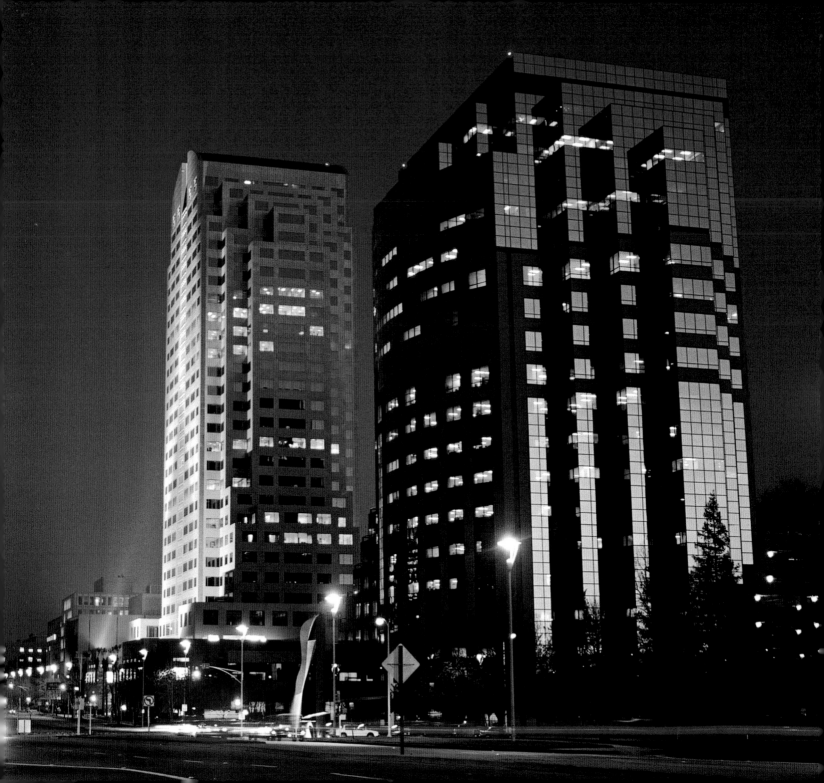

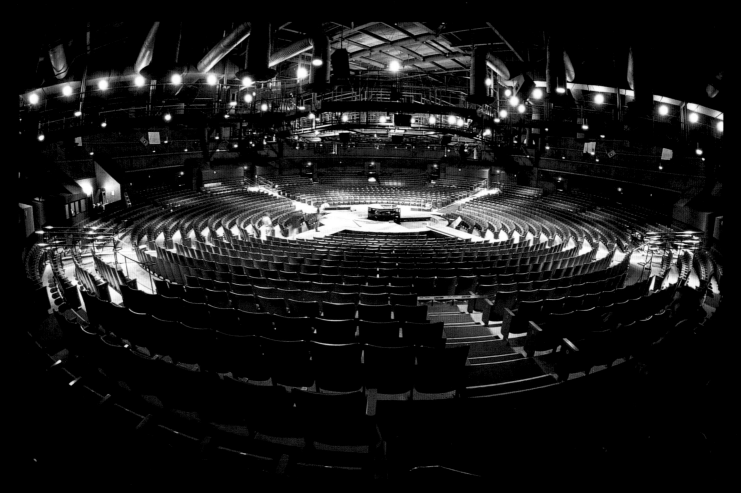

FACING PAGE: City streetscape on a balmy night near the Capitol Mall. This busy area of town mixes extensive commerce with museums, restaurants, a theater, and other urban amenities.

ABOVE: California Musical Theatre (established in 1949 as Sacramento Light Opera Association) is the capital city's oldest professional performing arts organization. They originally performed in circus tents, the first of the new "tune-tents" west of the Mississippi. Today, the group's Wells Fargo Pavilion in-the-round venue is true to the tradition of tent theatre.

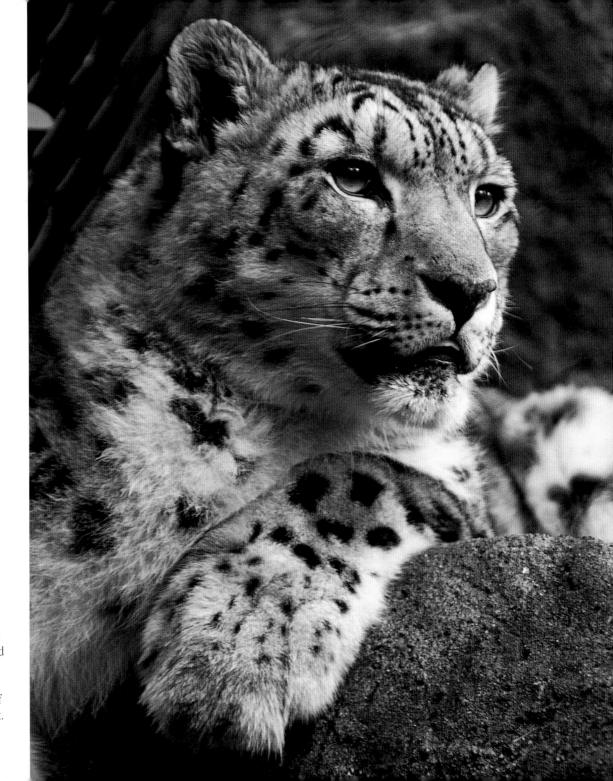

Begun in the 1920s, the Sacramento Zoo now covers 14.3 acres and encloses animals in natural settings. In the 1990s, the zoo added the Rare Feline Center, which houses endangered cats such as this snow leopard. A mixed species habitat for endangered red pandas was built in 2000, and the breeding pair has produced several cubs, one of which can be seen at the right.

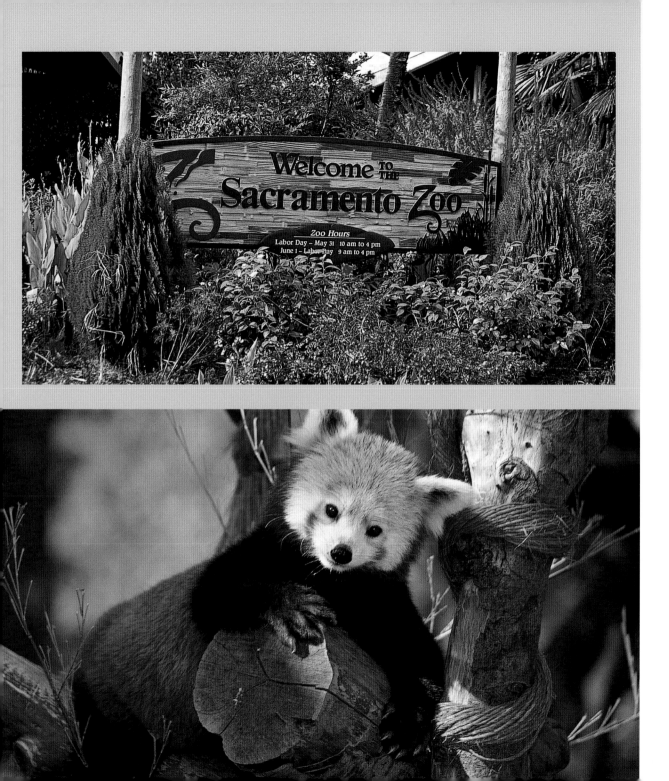

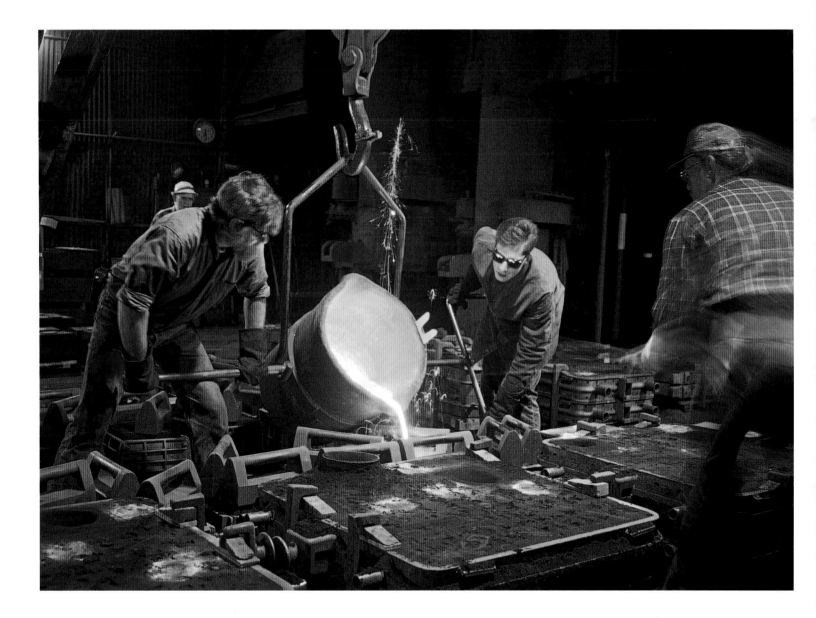

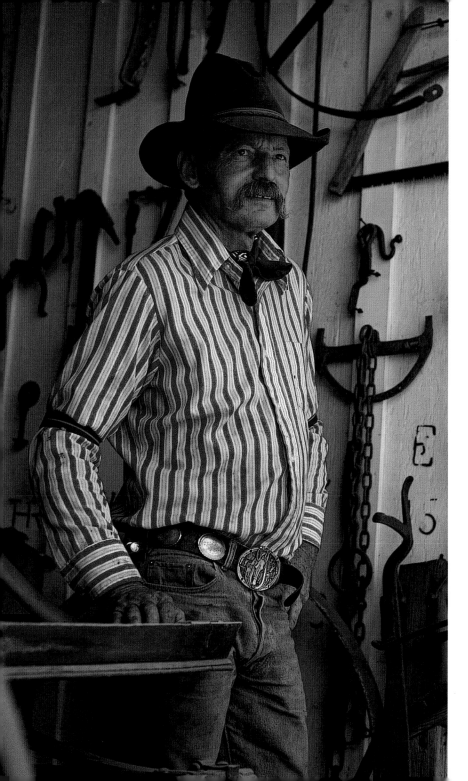

ABOVE: Movie-making and California are nearly synonymous, and who cares about the actual climate when fake snow can make even Sacramento look like a wintry wonderland?

LEFT: Ron Scofield makes wagons and stagecoaches the old-fashioned way in Fiddletown. During the Gold Rush, Fiddletown was a sprawling collection of shacks and miners' tents. It boasted the largest Chinese settlement in California outside of San Francisco.

FACING PAGE: Located in Sutter Creek near Sacramento, the Knight Foundry Historic Water-Powered Iron Works has been reopened as a skills training center for traditional industrial metal-working crafts and as a living history center.

FACING PAGE: As this label display in the Gold Rush History Center of the Discovery Museum attests, the Sacramento Valley is one of the world's most productive regions. One third of all Central Valley employment is farm-related. This display of preserved fruits and vegetables shows off some of the area's bounty.

RIGHT AND BELOW: The California State Railroad Museum in Old Sacramento preserves the best of the rail travel era. Exhibits range from displays covering the social issues of the time to presentations of railroad logos and promotional artwork. Summer visitors can ride behind a steam locomotive on the museum's Sacramento Southern Railroad.

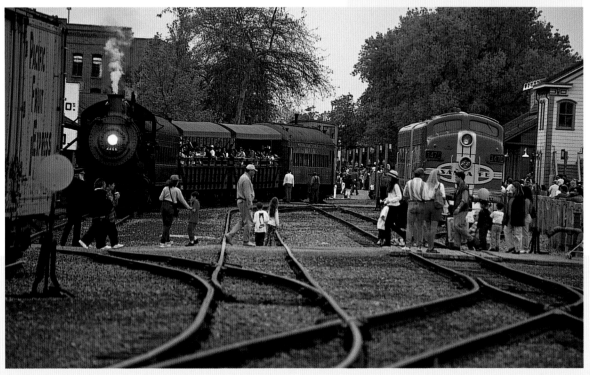

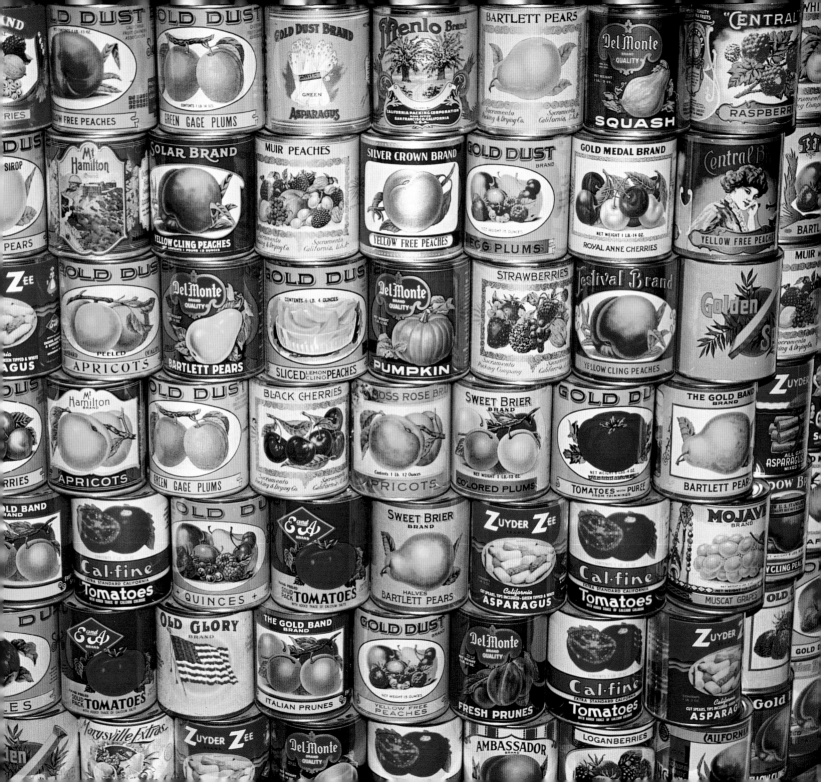

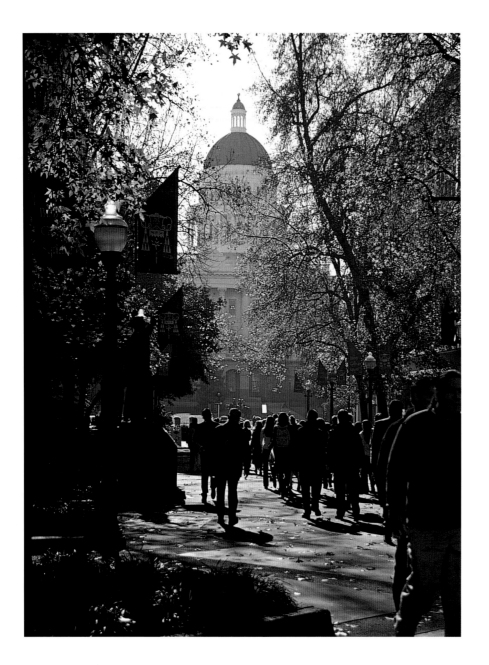

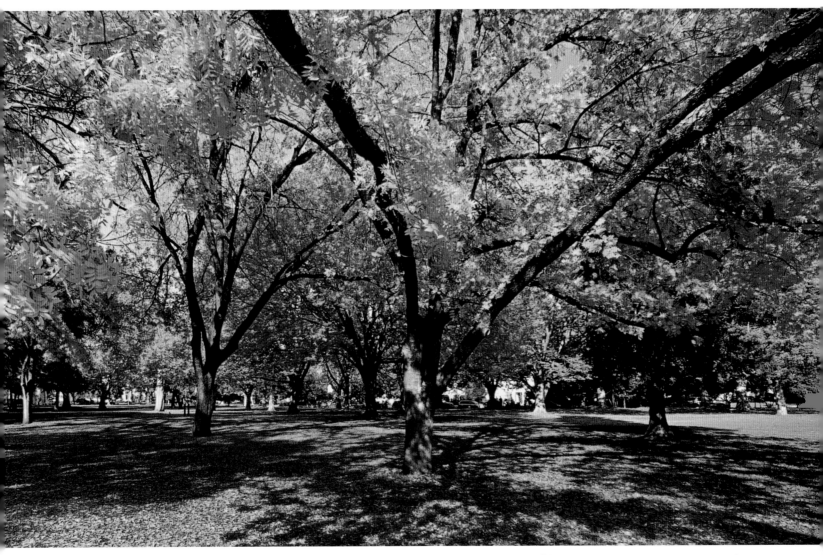

ABOVE: Sacramento's restful William Land Park provides a shady spot for picnics, walks, and simply enjoying autumn foliage.

FACING PAGE: A domed rotunda separating the two houses of the legislature is a feature of nearly every state capitol in the U.S. Here, Californians are headed to their capitol to observe or participate in modern lawmaking and other functions of state government.

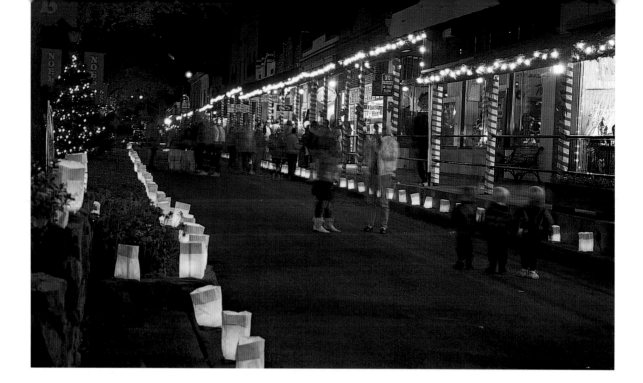

ABOVE: Holiday luminarias brighten the paths along Sutter Street in nearby Folsom, as revelers linger outside to window shop.

BELOW: Memorial Auditorium is part of the Sacramento Convention Center. Updated and renovated in the early 1990s, the auditorium now hosts numerous civic events.

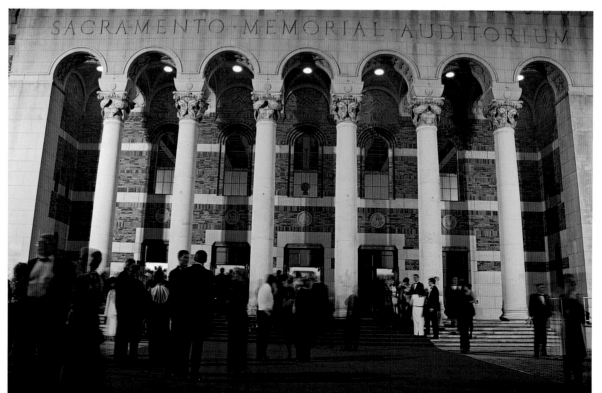

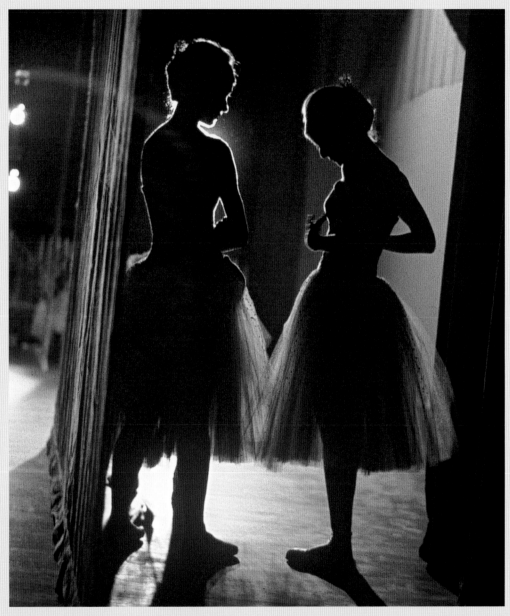

Holiday festivities are made complete when you see beautiful ballerinas dancing *The Nutcracker.*

ABOVE: Sacramento embraces a diverse ethnic population. Seen here are celebrants of the Portuguese Holy Spirit Festival Parade, held in May.

RIGHT AND FACING PAGE: Cinco de Mayo marks the victory of the Mexican Army over the French at the Battle of Puebla on the morning of May 5, 1862. The celebration in Sacramento includes traditional Mexican music, dress, and dancing, as well as contemporary Latino performers of original music.

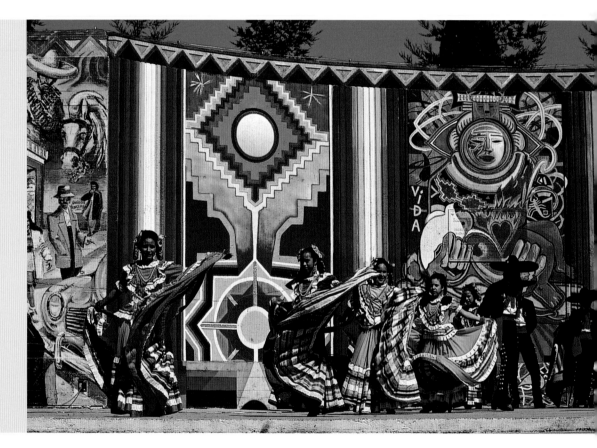

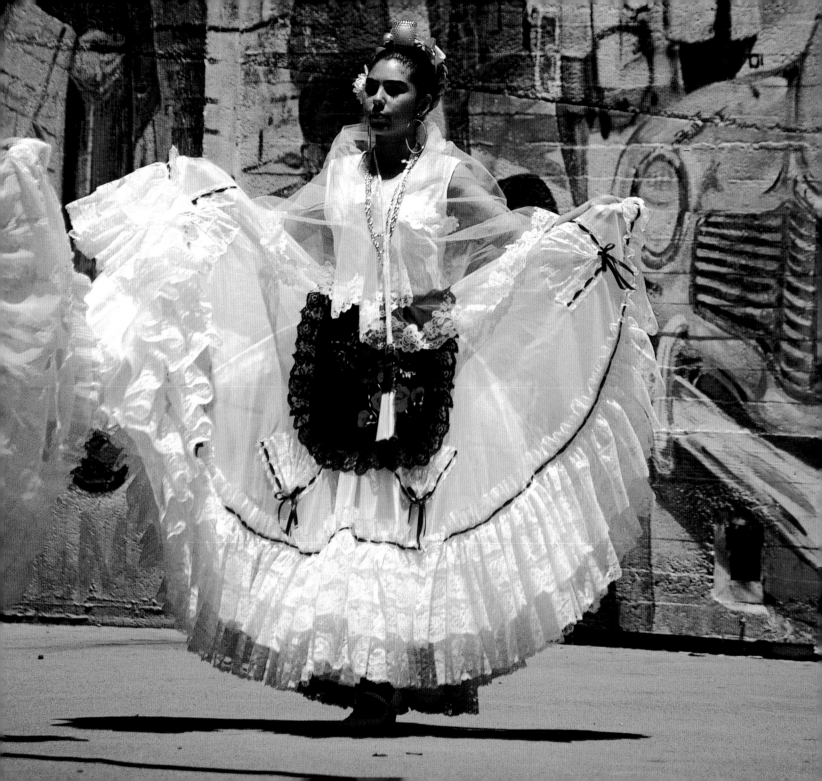

RIGHT: The Crest Theatre began as a vaudeville stage, and now showcases films and live performances within its fabulous gold-leaf, art deco interior.

FAR RIGHT: The original sign for Tower Records (plus cosmetics and films) in Sacramento was restored by Pacific Neon Co. in the early 1990s.

BELOW: You can spin wildly through the air on the midway rides at the California State Fair during August.

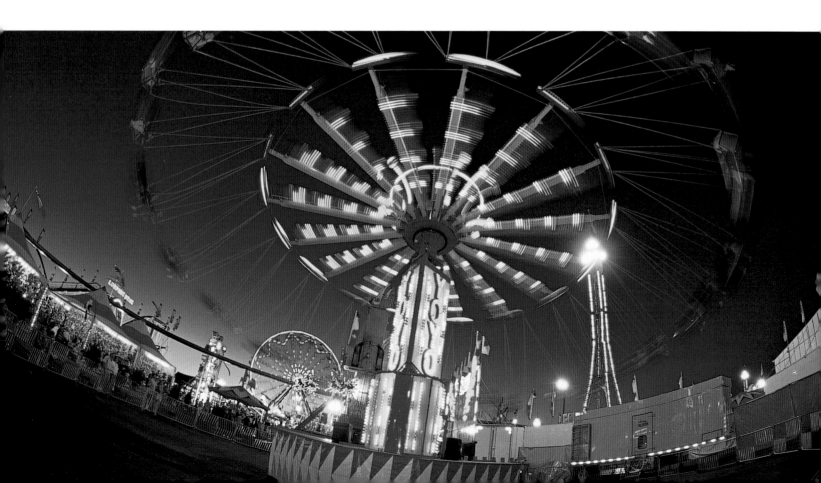

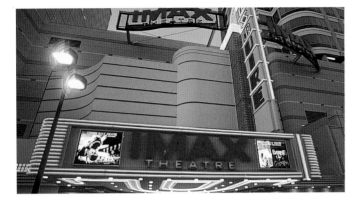

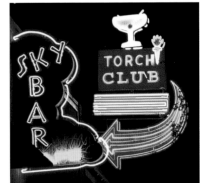

FAR LEFT: Esquire IMAX Theatre in downtown Sacramento screens films in both 2D and 3D.

LEFT: The Torch Club and Sky Bar neon signs compete to attract your attention—and your patronage.

BELOW: Hot licks blast out of a trombone during Memorial Day Weekend's annual Sacramento Jazz Jubilee.

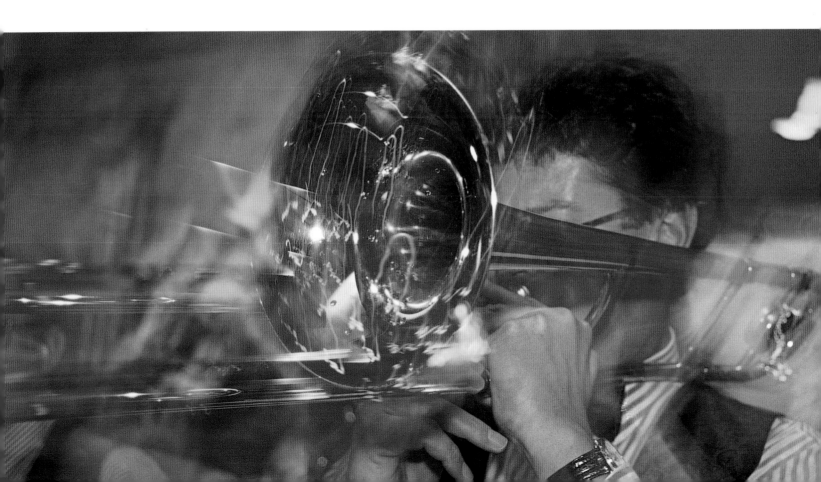

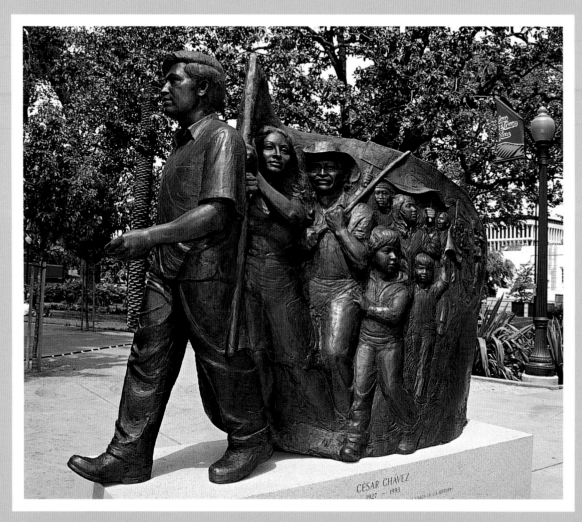

Cesar Chavez Memorial Plaza, with its statue of Chavez and workers, is a focal point in Sacramento, where more than 130,000 people per year gather for various community activities and rallies.

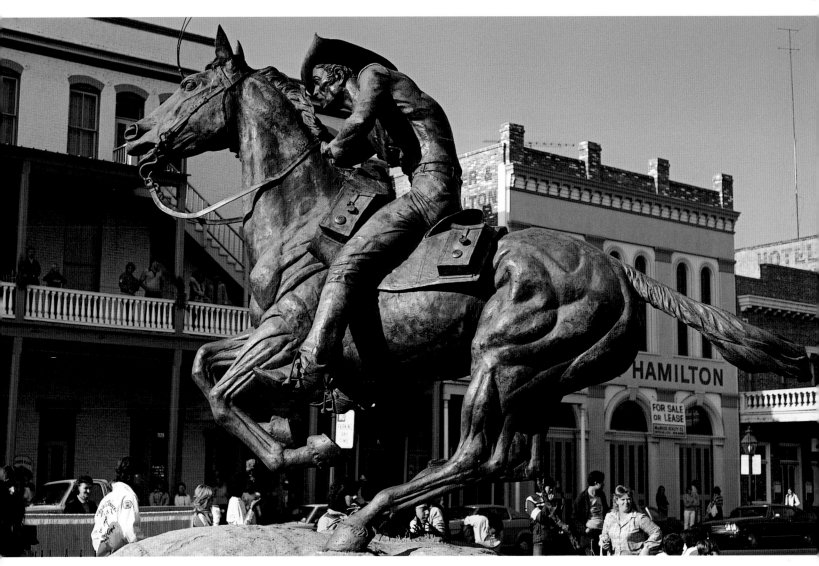

This statue was dedicated in 1976, as part of the national bicentennial celebration, to honor the contributions of the Pony Express.

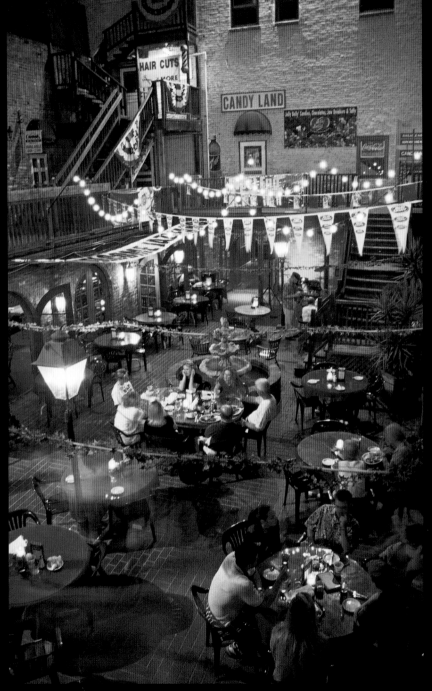

LEFT: Smooth, live, fusion-jazz music underscores the conversation of outdoor diners at Fulton's, located in a building constructed in the 1800s.

BELOW: A full exhibit hall in the California Museum for History, Women and the Arts. There are twenty-two museums in the Sacramento area.

BOTTOM: Tower Café has you dining among the pines and palms. Just try to choose which fresh dessert to have there, after attending a high-end art flick or foreign film at the distinctive Tower Theatre.

FACING PAGE: This formal evening event is being held in Westfield Downtown Plaza, which has 109 shops, eateries, and services.

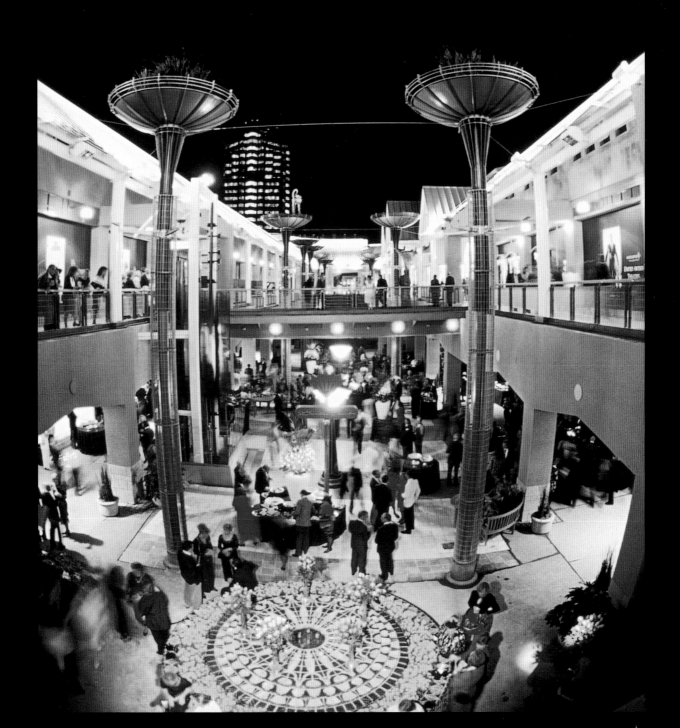

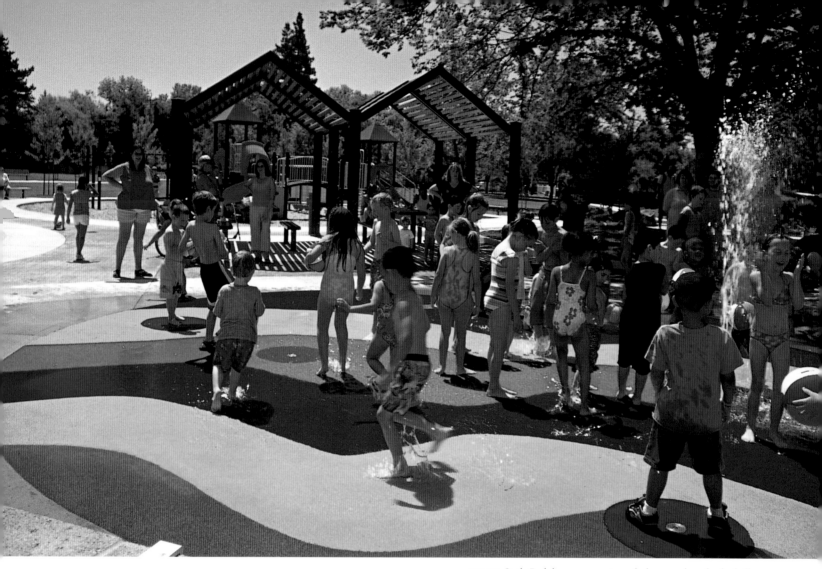

ABOVE: Seely Park has a new water splash area, plus a basketball court and extensive picnic facilities.

FACING PAGE: Outfitted for wheeled fun. Get bicycling route maps of Sacramento's extensive trails at www.saccycle.com.

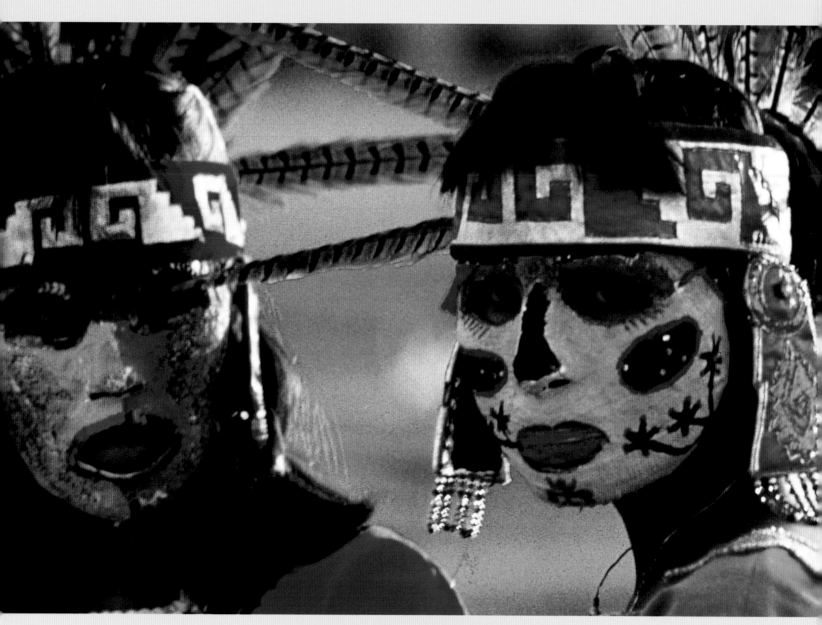

ABOVE: Day of the Dead, on the first and second day of November, honors relatives and friends who have died. The holiday, celebrating their spiritual return to Earth to share a special feast with the living, is rooted in the ancient history of Mexico's Aztecs.

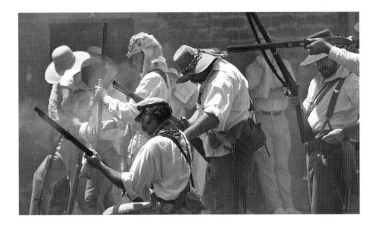

LEFT: Living History Days at Sutter's Fort State Historic Park. The park hosts several re-enactments of mountain man and pioneer life throughout the year.

BELOW: Buffalo soldier re-enactors at a Juneteenth celebration in Sacramento. Since June 19, 1865, this jubilee has celebrated African-American emancipation and emphasized education and achievement.

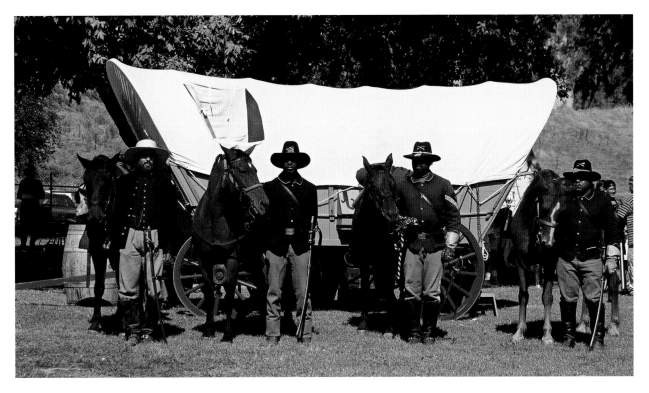

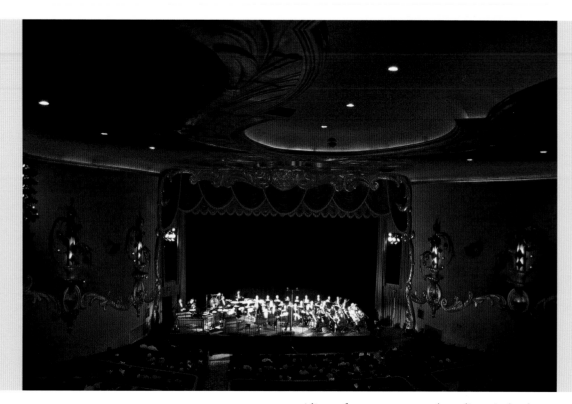

ABOVE: A live performance entrances the audience in the elegant, elaborately detailed Crest Theatre. The historic performance and film venue was completely restored in 1995.

FACING PAGE: Constructed in 1926, Memorial Auditorium fell into severe disrepair in later years. It was reopened in 1996 after a ten-year closure and renovation, and now hosts a wide range of community activities.

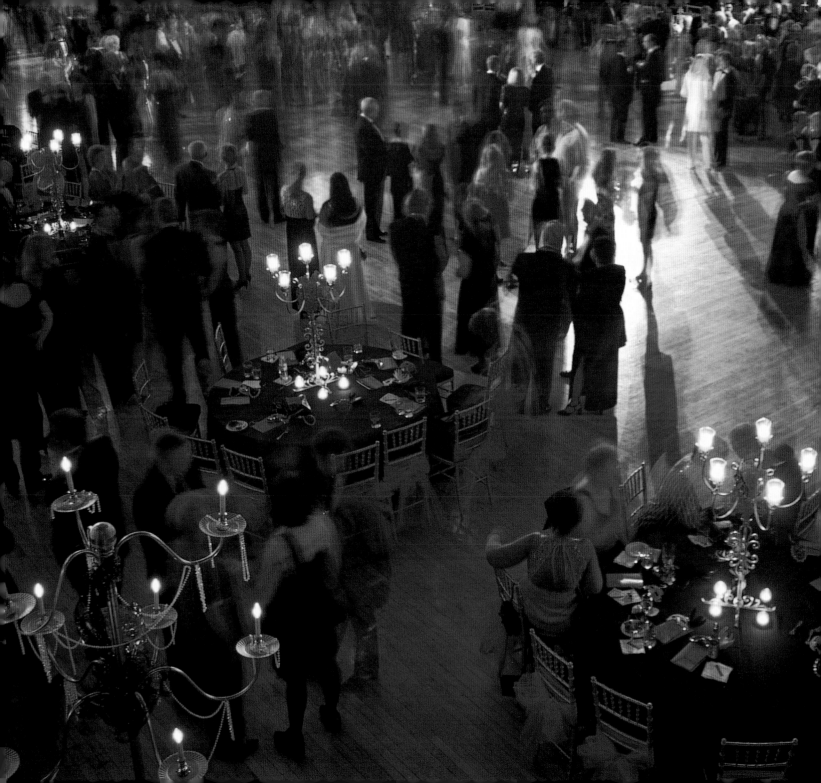

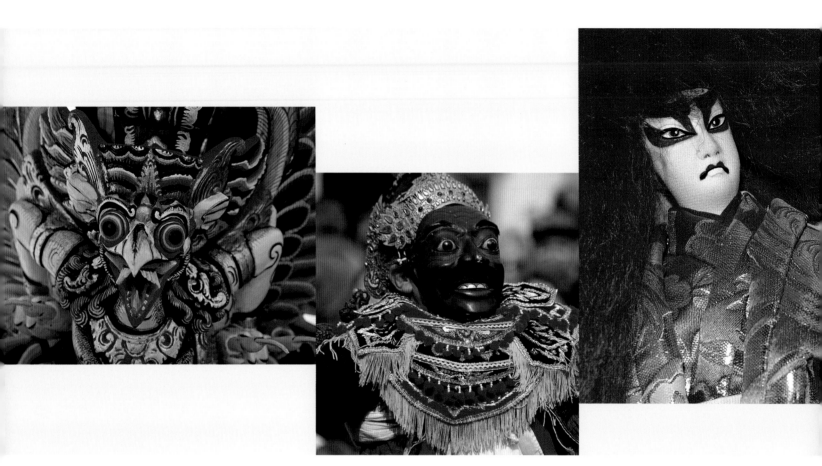

ABOVE: This Garuga mask is of Hindu origin. Each May since 1993, the Pacific Rim Street Fest has showcased the rich diversity of many cultures.

ABOVE: A traditional Balinese mask is displayed at the Pacific Rim Street Fest, which features cultural programs, entertainment, art, and food.

ABOVE: This Japanese doll is on exhibit at the Pacific Rim Street Fest, which enhances the community's knowledge of Asian/Pacific Island cultures.

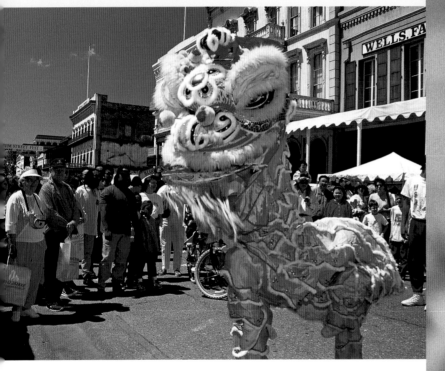

ABOVE: This flamboyant costume would catch anyone's attention, even with all the other distractions of the Pacific Rim Street Fest.

RIGHT: A young girl is adorned for the Korean Full Moon Harvest Festival in mid-autumn.

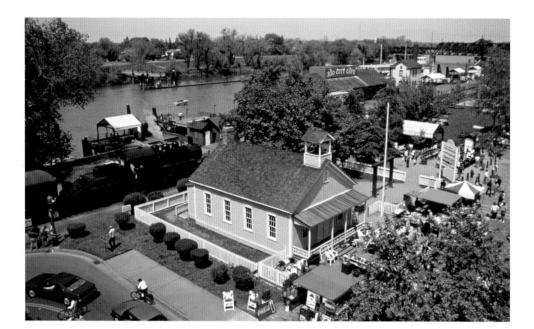

ABOVE: Old Sacramento School-house Museum is a replica of traditional one-room schoolhouses of the late 1800s. Costumed schoolmarms and schoolmasters sometimes lead visitors in a lesson.

BELOW: The schoolhouse displays textbooks, quill pens, and a bell to call in students from recess, as well as a pot-bellied stove, vintage student desks and other furnishings typical of the period.

FACING PAGE: Patty Reed's doll survived the Donner Party's ill-fated trek over the high Sierras. Patty survived, too. Her doll now is exhibited at Sutter's Fort State Historic Park.

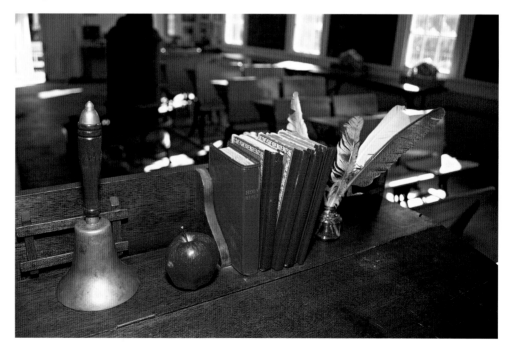

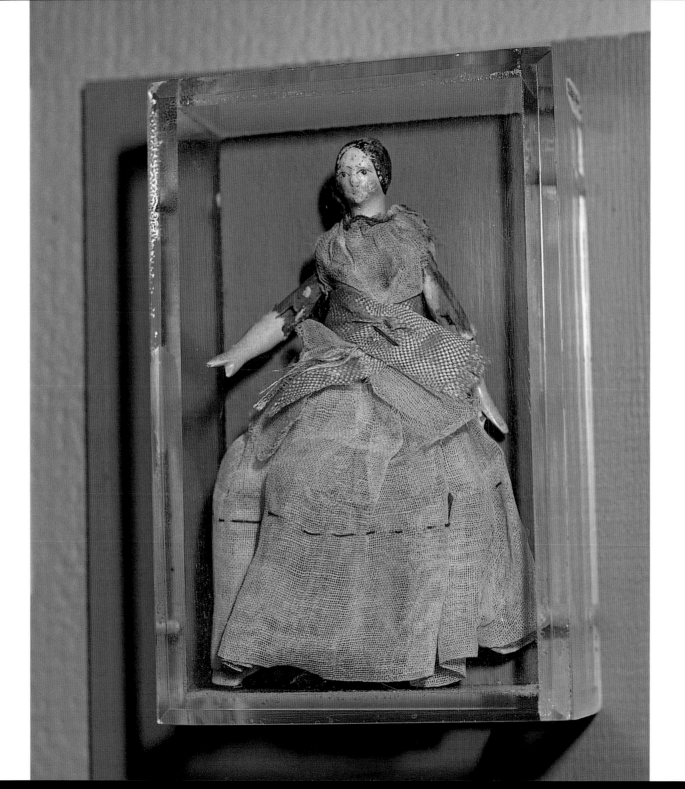

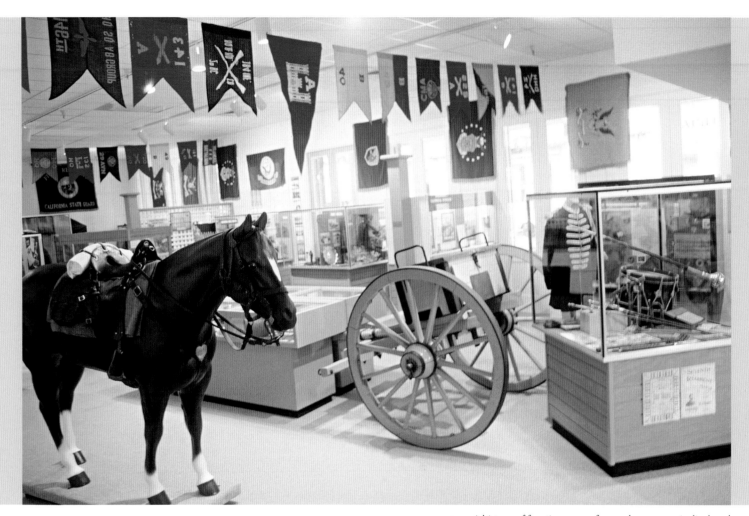

ABOVE: A history of frontier-era warfare and weaponry is displayed at the California Military Museum in Old Sacramento.

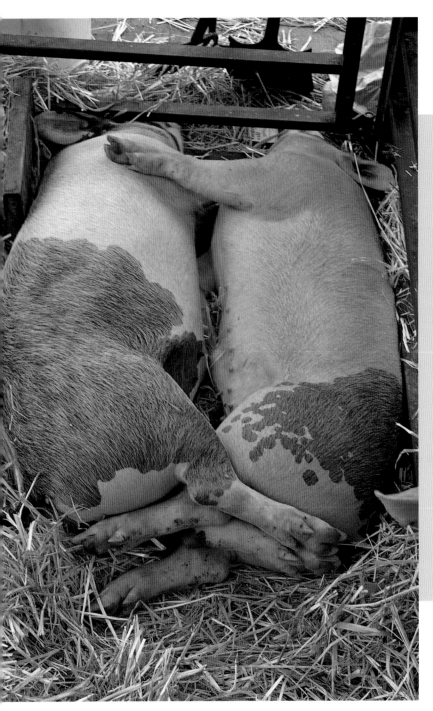

ABOVE: The annual California Expo and State Fair features big-name entertainment, competitions, carnival rides, and other attractions and activities for the family.

LEFT: Exhausted from all the bathing and primping, two pig siblings cuddle up for a nap at the Sacramento County Fair.

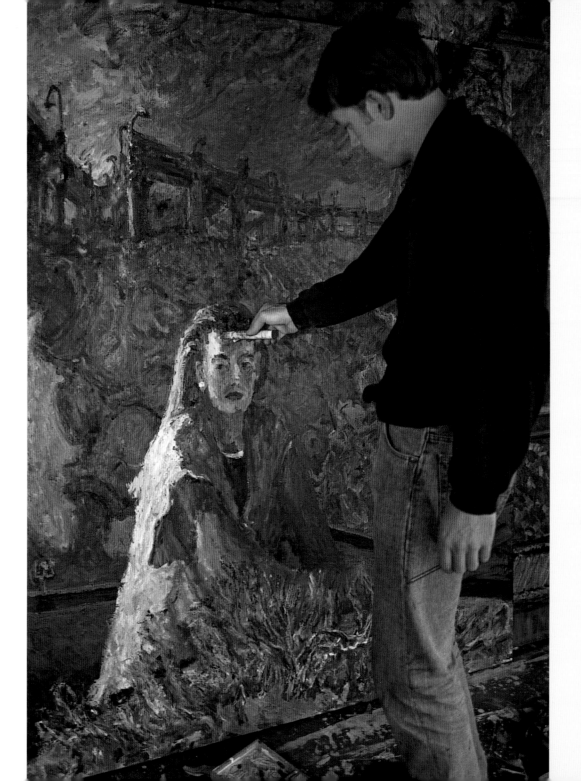

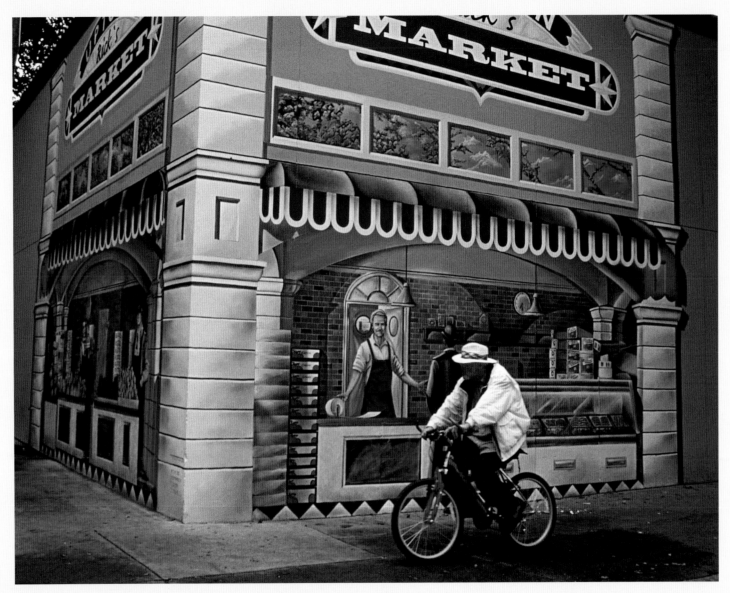

ABOVE: Much more interesting than a plain corner wall, Rick's Uptown Market grocery store is painted to portray an inviting scene.

FACING PAGE: Sacramento artist and photographer Jeff Myers puts the finishing touches on a life-size oil painting.

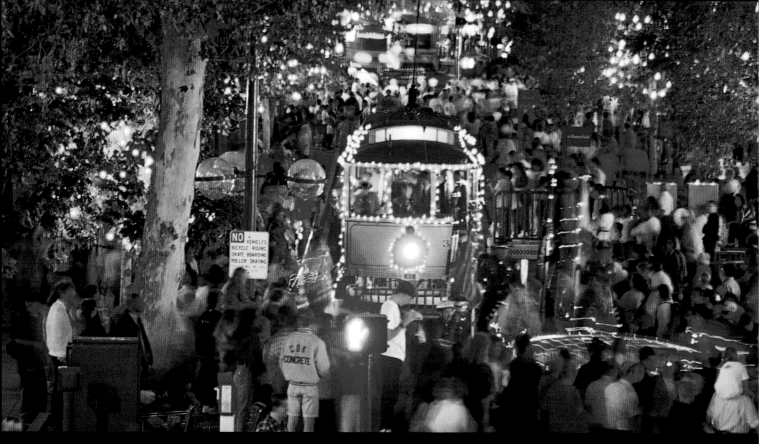

ABOVE: Alive and lively, midtown's K Street is one of Sacramento's hottest gathering spots and is filled with bars and nightclubs.

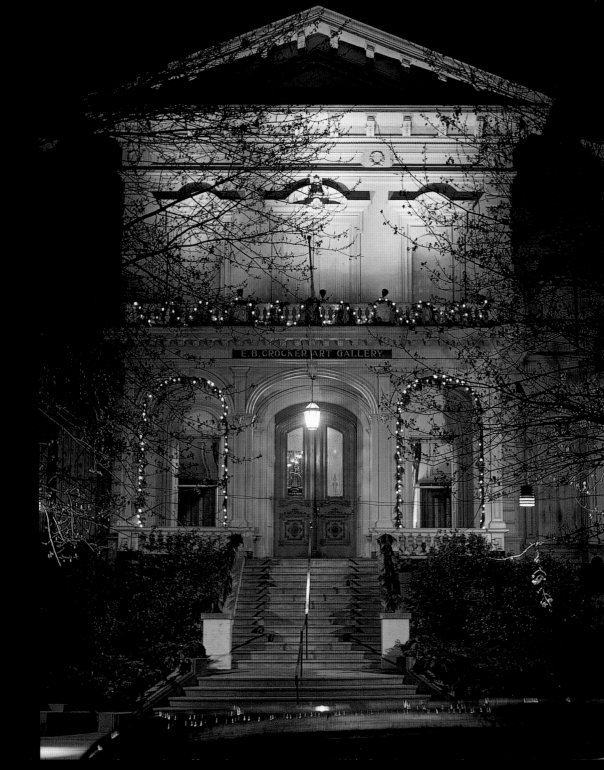

RIGHT: Presented "in trust for the public" in 1885, Crocker Art Museum today displays about twenty changing exhibitions every year, and permanently holds more than 14,000 works of art. It is the oldest public art museum west of the Mississippi River.

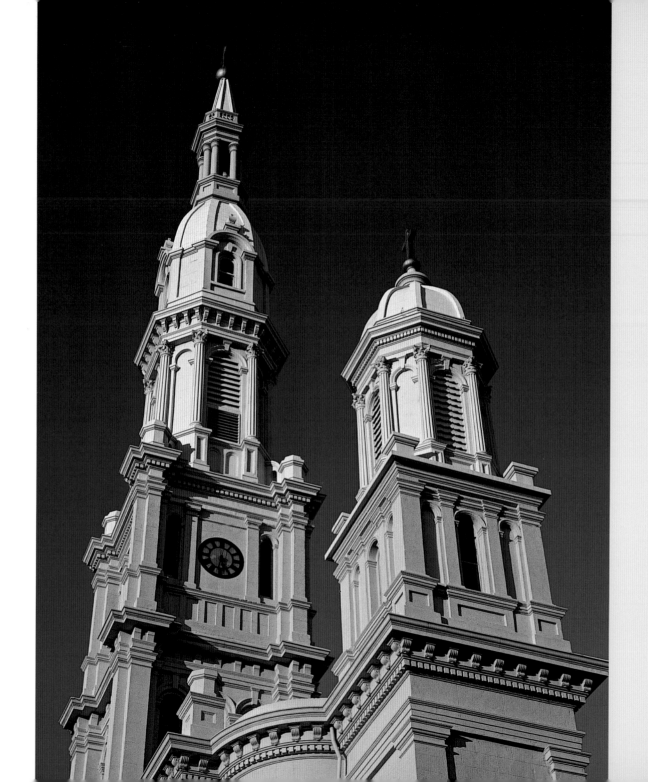

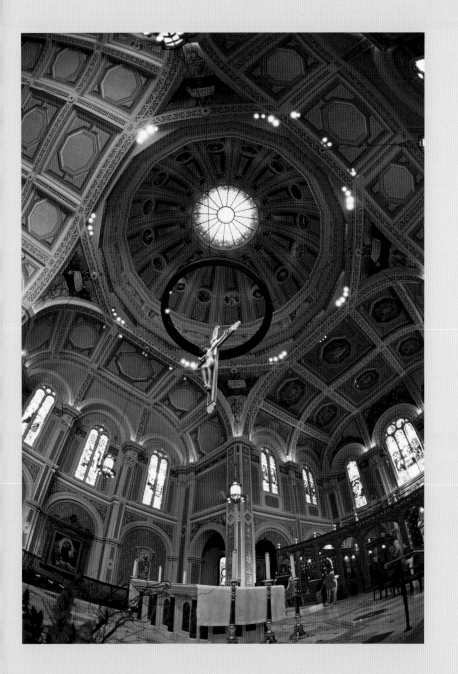

ABOVE: Sacramento's historic City Hall sports elaborate architectural flourishes and details.

LEFT: In 1932, the cathedral's dome was dismantled for structural reasons. It was rebuilt in 2005, using an interpretation of the original. The sixteen roundels in the dome tell the story of the Eucharist.

FACING PAGE: The spires of the Cathedral of the Blessed Sacrament, built in 1889, are an unmistakable part of Sacramento's skyline.

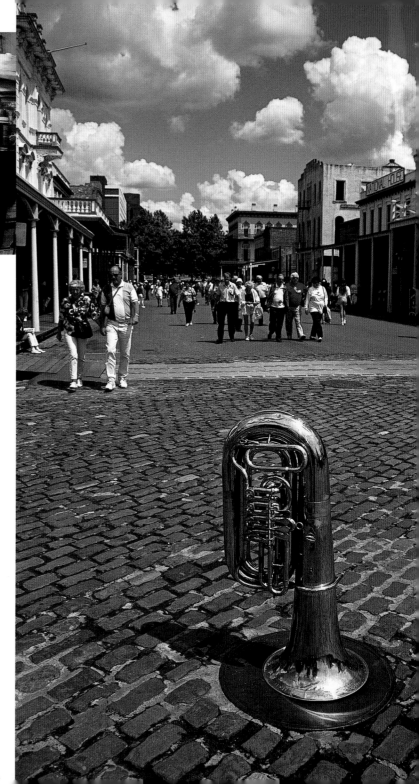

PHOTO BY JESSI JAMES

TOM, SALLY, AND JEFF MYERS
biographies

After serving in World War II and the Korean War and working at several major newspapers, Tom Myers met his wife Sally in the Sierra Camera Club of Sacramento in 1962. Now, with their son Jeff, they have amassed a stock image file of more than 700,000 photographs, which they sell directly to publications.

Their clientele includes hundreds of magazines, including National Geographic Society and National Wildlife Federation publications. They have also sold images to advertising agencies, greeting card companies, and book publishing companies in Canada, England, Finland, and France.

Tom Myers Photography continues to adapt and thrive and implement new technologies as it keeps up with a steady volume of business. Besides working as a photographer, Jeff Myers is also a fine artist who has exhibited paintings in numerous galleries over the years.

The Myers have photographs of a variety of subjects, but they specialize in images of California and the West. "No two days are alike," says Sally. "We may spend much of our day sorting through new images and filling orders; but we also travel and cover local events." Orders are often filled at night, as Tom works during the wee hours, and mornings are usually busy as local customers come by to pick up their photographs. Afternoons are left open for shooting. This photograph above was taken in Tom's office—not one of Sacramento's neatest!

The Myers can be reached at www.tommyersphotography.com

RIGHT: Tootle a tune, anyone? This tuba might look inviting to many of the talented musicians who abound at the annual Sacramento Jazz Jubilee.